BILL MASON
CANOESCAPES

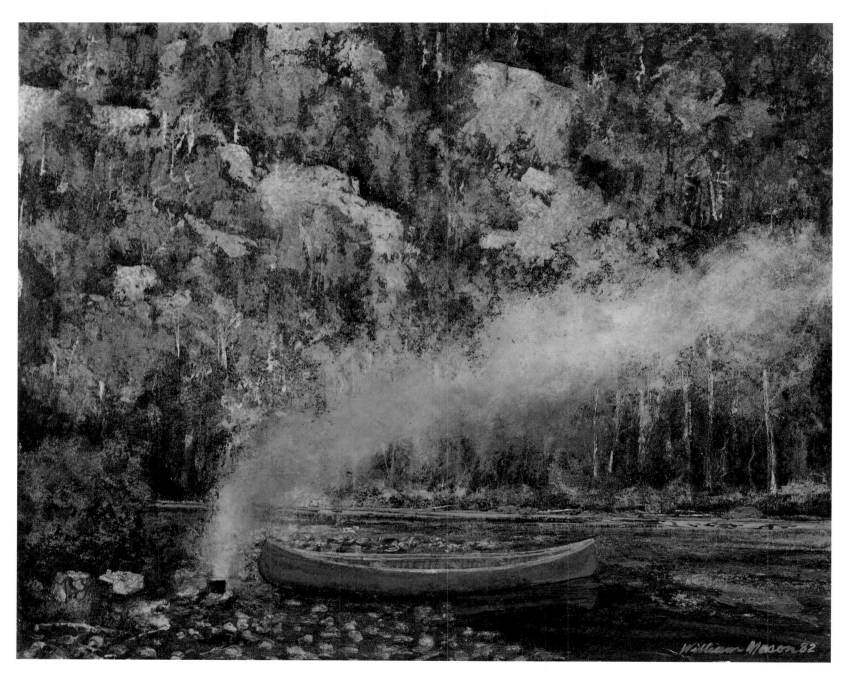

CAMPFIRE, PUKASKWA RIVER 12 x 10 inches

BILL MASON

CANOESCAPES

Foreword by

CHRISTOPHER CHAPMAN

A BOSTON MILLS BOOK

Copyright © 1995 Bill Mason Productions Ltd.

First published in 1995 by
The Boston Mills Press
132 Main Street
Erin, Ontario
N0B 1T0
(519) 833-2407 fax (519) 833-2195

An affiliate of
Stoddart Publishing Co. Limited
34 Lesmill Road
North York, Ontario
M3B 2T6

DESIGN: Andrew Smith

PAGE COMPOSITION: Joseph Gisini / Andrew Smith Graphics Inc.

Printed in China

COVER: *Fire at the Confluence of Little Nahanni and South Nahanni Rivers*
BACK COVER: *Chestnut Prospector Canoe*

Canadian Cataloguing in Publication Data

Mason, Bill. 1929–1988
 Canoescapes

ISBN 1-55046-141-9

1. Mason, Bill, 1929–1988. 2. Wilderness areas in
art. 3. Canada in art. 4. Canoes and canoeing –
Canada. I. Title.

ND249.M37A4 1995 759.11 C95-931053-3

Stoddart Books are available for bulk purchase for sales promotions,
premiums, fundraising, and seminars. For details, contact:

Special Sales Department
Stoddart Publishing Co. Limited
34 Lesmill Road
North York, Ontario Canada M3B 2T6
Tel. 1-416-445-3333
Fax. 1-416-445-5967

CONTENTS

Acknowledgments . 7

Foreword . 8

Introduction . 10

Swamps . 16

Shoreline Impressions . 30

Miniatures . 50

Frozen Shores . 60

Cliffs and Rocks . 68

Storms . 82

Crashing Surf . 106

Waterfalls . 114

Rapids . 134

Campsites . 146

Afterword . 156

List of the Works . 158

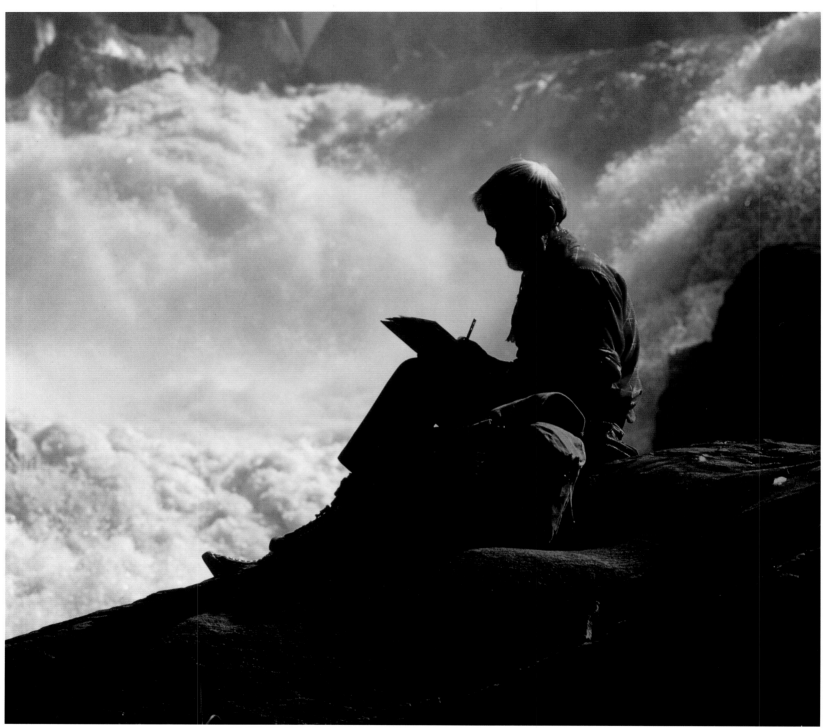

ACKNOWLEDGMENTS

MOST OF BILL'S FRIENDS and acquaintances believe his chief obsession was the canoe. But his first love was really painting. During his career with the National Film Board of Canada he periodically "disappeared" for short periods to paint. But he always returned to filmmaking because there was always another compelling film to make. However, after completing his last film, *Waterwalker*, in 1985 and the book *Song of the Paddle* in 1988, Bill returned to painting. When he learned of his illness he decided to take a last canoe trip down the Nahanni River in the Northwest Territories with his family and friends. On his return he did some final paintings of Lake Superior and struggled to finish the text for *Canoescapes*.

This is the book as Bill designed it. Some of the text was deleted because the original paintings could not be found and some of the paintings have no text because he was unable to finish it.

The publication of *Canoescapes* is the fulfillment of a promise made to Bill a few weeks before his death. Because Bill's writings and paintings are such a personal and intimate expression of himself, this has been, for me and my family, a bittersweet experience.

My heartfelt thanks to my children, Becky and Paul, and to their respective spouses, Reid and Judy. Their incredible effort has made this promise to Bill come true.

Special thanks to Wilber Sutherland for his constant support and encouragement and to Lloyd Seaman for his help with the text. Other friends who contributed to the momentum include Jim Raffan, Susan Buck, Ken Buck, Don Campbell, John Irwin, Wally Schaber, David Andrews and Christopher Chapman.

Thank you to those people who allowed us to borrow their original paintings, leaving blank spaces on walls while paintings were being photographed.

And thank you, Bill, for teaching us that "to fully enjoy nature, one must learn to see."

<div align="right">

JOYCE MASON

</div>

KEN GFELLER

FOREWORD

SITTING IN A TANGLED forest by a small stream that winds through our property, I am thinking about Bill, our friendship, his remarkable accomplishments and the passion for the Canadian wilderness.

It was in 1956, forty years ago, that Bill and I spent three intensive weeks in Quetico Provincial Park in Northern Ontario, where I was making a film. I wanted the film to convey the spirit of Quetico and the spirit of canoeing in this remarkable wilderness park of over two million acres. I heard about a passionate canoeist, Bill Mason, and hired him to join me as an assistant, canoeist, guide, cook and all that went with it. I quickly made him the star, a "lone canoeist in Quetico." We had a great time, but it was a hectic, stressful period due to extremely temperamental weather conditions. I'm sure Bill's 16-foot canoe had an extra curve to its shape from carrying the two of us, all the food, camping gear, plus the camera equipment for three weeks. I know I developed extra curves from the portages.

There appeared to be a mutual friendship between Bill and his canoe. One could see the remarkable affinity he had to the rhythm of wild, free water and his excitement in learning about it. It was this intense interest and study of everything around him that inspired his films and books, and that fed his painting talent. I will never forget Bill's excitement when he saw the finished film, *Quetico*. He sent me wonderful cartoon pictures of himself jumping up and down with joyous abandon. This was Bill. When he was excited, he was ecstatic.

Over the next thirty years Bill literally exploded with films, books and paintings. He and I stayed close for the rest of his life. It was a remarkable friendship, more surprising because we did not get together often. I regret not having more experiences with him during his lifetime of whitewater and wilderness exploration.

Bill's creativity was deeply personal. He knew what he wanted and fought hard to achieve it. His family and close friends shared some of his turmoil, but for them it was balanced by his contagious, positive expression of life.

He tackled immense whitewater rapids and knew what it was like to be close to his God, not only at a moment that might end his life, but also in the stillness of a lake, river or forest. He knew mountain rivers, barren lands, tundra, the Arctic, Precambrian Shield and Lake Superior. I never felt he pitted himself against the power of nature in a macho manner or to prove himself. He did it because he knew he was part of it and to be part of it you had to let it teach you, no matter what the odds. His end came not from challenging the power and drama of wilderness but from inside his body. His strength came from faith in God, as well as from the world of nature that he nurtured and that gave him so much.

Bill was driven by a mission. That mission was to show us the beauty and drama of our natural world and to plead for its recognition. His tools were his creative gifts. He spoke to everyone through his films and books. *Canoescapes* is an ambitious, vivid, visual poem of Bill's feelings — an intriguing companion volume to his canoeing and camping books. Through Bill's descriptive words in *Canoescapes* we share his thoughts and explore the origins of these paintings and his technique. These paintings are a record of passion from someone who discovered his own painting expression and was in the process of exploration. These paintings forever capture Bill's feelings for the elements of our earth.

I want to end this foreword with passages from a letter Bill addressed to the hundreds of people who wrote him upon learning of his illness. His letter reflects a lot about his own spirit:

> *There was nothing they could do. Chemotherapy has little to offer and is such a long shot that I would much rather enjoy quality time rather than quantity.*
>
> *The thought has crossed my mind that maybe I should try an alternative life style such as smoking, drinking, carousing and junk food! But I couldn't get that one by Joyce.*
>
> *Joyce, Becky, Paul, Judy and Reid have been absolutely amazing through all this. We have taken control over the situation and we are doing just fine. We live and cherish each day at a time, as always. I want to spend as much time as I can painting, writing, smelling the flowers and watching the clouds.*
>
> *I spend considerable time lamenting about what a mess I'll be leaving it (the earth) in. However, I have never believed in harping on the negative. My optimism is rooted in my faith that God has not forsaken us.*
>
> *I have no sense of self-pity or why me? Sure, I would love to be around a lot longer. There are so many things to do and rivers that need canoeing. And what a shame that a sparkling hockey career is terminated right at its peak. (Last year I got more goals than Gretzsky did!)*
>
> *It's a bit of a shock to be stuck in bull low when I've spent a lifetime in 4th gear. I'm feeling pretty wobbly and tire quickly, but I am very happy with my painting and writing. I am able to get going and accomplish something each day thanks to Joyce, who gives me enough but not an overdose of sympathy.*

Thanks, Bill, for giving us *Canoescapes* to add to your profusion of joy over our natural heritage.

Christopher Chapman, 21 April 1995

INTRODUCTION

I HAVE ALWAYS BELIEVED that the Canadian canoe is one of the greatest achievements of mankind. There is nothing so aesthetically pleasing and yet so functional and versatile. It is as much a part of our land as the rocks, trees, lakes and rivers. Most of my enjoyment and creative endeavours in the Canadian wilderness have been from a canoe, so it seems quite logical to call this book *Canoescapes*.

The canoe shown opposite is the Chestnut Prospector, the most versatile canoe ever made. It is not a specialized canoe, but a canoe that performs well in all conditions of wind, waves, and rapids, on portages and even in silent, hidden places. It takes as much skill and artistry to paddle a canoe well as it does to paint a picture of it well. In this painting I wanted to capture the look and feel of a well-worn travelling companion. There's hardly a rib or plank that isn't cracked, but after a quarter of a century it's still wearing its original canvas. I have many other canoes that I use for playing in rapids or for canoeing whitewater rivers, but I was in this old Prospector for most of the places portrayed in this book.

———•—•—•———

The compulsion to create is something I was born with. I am happiest when I am painting, photographing or writing. Or to put it another way, I am unhappy when I'm not creating, unless I'm doing something active, like running whitewater, or skiing or playing hockey. There are many aspects to the enjoyment of creativity. There is the contemplation of doing something creative, the act of creation, the sense of accomplishment at having created something, and finally, experiencing others' reactions to what you have created. Some artists claim that what people think of their work is not important. They claim to create for themselves, and I do too, but I have to admit that it is always a delight to have people respond to one of my paintings. When you create a painting and put a frame around it, the creative act is finished. If somebody doesn't buy it you get to keep it. However, when you write a book or make a film, people have to like it or it won't get printed or distributed. Or, if you do get it printed and distributed and nobody likes it, you aren't going to get the chance to do it again unless you are independently wealthy. With painting you just buy more paint and canvas and have another go at it. For me, creativity has a lot to do with a sharing of what I have discovered or what I enjoy doing. My films on wolves, whales,

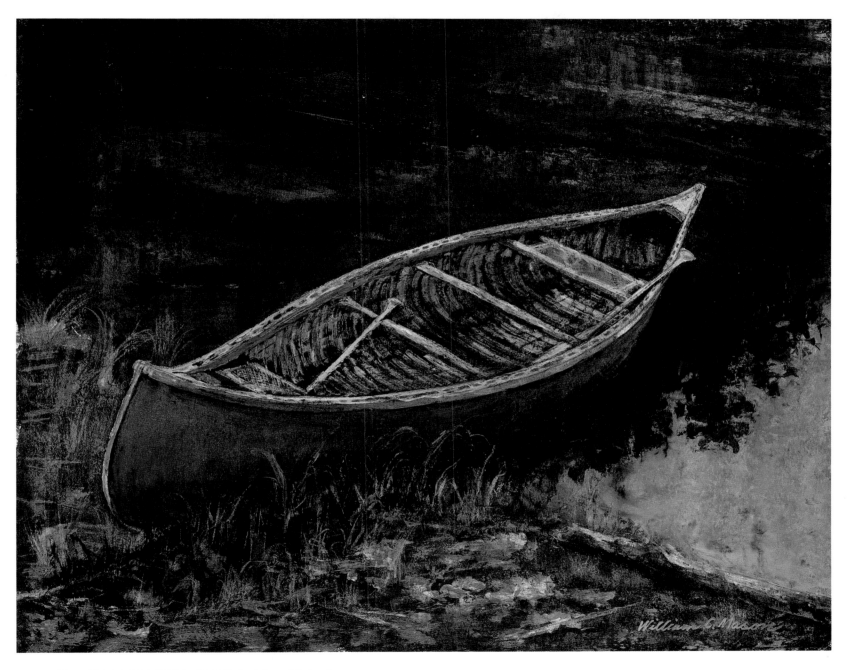

CHESTNUT PROSPECTOR CANOE 12 x 10 inches

mountains, sunken ships and canoeing have enabled me to travel and live in remote wild places and to share my experiences with a very wide audience.

But painting is where I began, and it is very exciting to return to my original profession, to share the natural world through painting. It is the simplicity of paint on paper that I find the most satisfying. There is no one and no technology between me and the finished work of art, and no one to blame if it doesn't work. Much of what I read about art is beyond my power of comprehension. In some cases I haven't the foggiest idea what they are writing about, and sometimes I think the writers, reviewers or critics don't know either. However, since I did these paintings and I've been to all the places that inspired them, you might enjoy reading something about them. You might even want to go there to experience the real thing.

In some cases the paintings represent the scene quite accurately, in others creativity has taken precedence and the actual scene has served only as inspiration for the painting. Many of my most creative or exciting paintings are done from rough sketches or from memory so that all of the unnecessary details have been filtered out by time, and all that's left is a feeling about what makes the place unique.

Quite often, circumstances dictate how a painting is done. Painting is something I have to do alone. When I travel on remote northern rivers it is with friends, since it's too expensive to charter flights by myself. However, when you travel with friends you can't have them standing by impatiently waiting to get going while you crank out your masterpiece. At least not with my kind of friends! We do allow lots of extra leisure time, but apart from quick sketches there still isn't enough time, so often I resort to colour photography.

There is a general feeling that paintings are tainted if colour slides are used as reference. I think this is possible, but more often these paintings simply lack individuality or uniqueness and can be boring. At first glance my paintings of Wilberforce Falls and Virginia Falls could fit within this category. When viewed through a magnifying glass, however, the feeling is much more spontaneous and painterly, as you will see in the detailed blow-ups. The vision I have of any particular place is incredibly elusive. For a painting to be right I have to be able to step back and say, "That's the way I feel about that place." Not how it looks but how it feels.

To fully enjoy nature, one must learn to see. It takes a special perception to see colour, texture, and design. A casual observer can exhaust the possibilities of a scene in a few minutes. An artist can spend days without seeing it all. At first the dark shadows behind the foreground trees are only that—dark shadows. But after a while you begin to see trees and rocks and shapes, and maybe even a bird or other animal. Certainly you will see textures and designs. My objective is to create a painting in which you can see different things each time you look at it. In my realistic paintings, the possibilities are more quickly exhausted than in the more impressionistic ones. I have reproduced small areas of some of my paintings; these become detailed paintings in themselves.

It might be of interest to provide some clues to the technique I have used. I have never divulged the entire process and don't intend to, at least not until I have mastered it, which probably will be never. Every artist strives for a way of painting that is unique or different—not just for the sake of being different, but to create in a manner that best expresses what the artist has to say. It could be the shape, colour, texture, the way the paint is applied, the subject matter, or a combination of all of these. The difference in my painting is the technique. I developed it twenty years ago while working in film animation. At the time I was working on animation backgrounds for a film portraying the creation of the earth. Using oil for animation backgrounds was unheard of because oil on canvas is so slow-drying, but I decided to try it on paper. To my complete surprise, the extremely flat surface necessary for animation background was retained while achieving a remarkably three-dimensional quality. And the paper absorbed the oil, causing it to dry quickly. I was so excited and anxious to explore my new discovery that I found it difficult to concentrate on the film.

For durability I use acid-free paper so the oil in the paint won't create a reaction. There are several reasons I like paper. It's one of the most durable natural materials to paint on, and yet its light weight is a great advantage when you have to carry everything on your back or in a canoe. But the most important attribute of paper is that it forces me to be spontaneous.

With my technique I can't salvage a muddy painting, because the brightness depends on the white paper shining through the paint. It is for this reason I don't overpaint, it's got to work on the first attempt. This is in

complete contrast to the impasto technique, using heavy brushstrokes, that I used more than twenty years ago. That technique was far too predictable, and not very adventurous. Now I use a palette knife almost exclusively, even for applying glazes. The palette knife is normally regarded as a broad painting tool, but I use it for the most minute detail. The clumsy nature of the knife forces me to be much more spontaneous than I would be with a brush. It's an adventurous and exciting way to paint. Often I give up after many tries and leave the subject alone for a year or two. Then I might try again. Virginia Falls is an example—there were more than ten attempts on this one. On the other hand, Wilberforce Falls, one of my most ambitious and difficult subjects, worked on the third try, and Denison Falls, another difficult painting, worked on the first attempt. Yet Cascade Falls required ten attempts. I can never tell in advance which subject will give me trouble.

Many of the most exciting paintings happen by accident when I am experimenting with textures. I'll see these rocks or trees or water surfaces emerging out of chaos. I'll see a place completely different from the one I am working on. I'll put a frame around it and there it is, a painting far better than the one that was in my mind.

In the eighties I heard a talk by the director of the National Gallery of Canada, who stated that she wasn't interested in collecting pretty pictures. In a way, I can see what she means. The reality of today is depicted by slabs of steel leaning against a wall, squares of copper laid out on the floor, strips of carpet piled in a corner, piles of Brillo cases, a collection of once-useful objects that have one common factor, they are all red. This is the curator's idea of what art is today, and I totally agree with her. For beautiful pictures you have to step back sixty or seventy years, to the Group of Seven, and even further back, to the Greek and Roman periods. Today we are removed from nature and live in a world created by our own hands. It is only natural that our art reveals our modern world and the contrast between chaos and order. I find little joy or pleasure in much of this kind of contemporary art. Conversely, I don't find realistic art all that interesting either, though I greatly admire the craftsmanship in some of it. We are in a strange period at the moment because no one in the art establishment ever calls a work of art a piece of junk anymore. The critics just ignore it. Maybe the reason is that many works of art that are now regarded as treasures were cruelly ridiculed in their day. For example, William Mallord Turner,

an eighteenth-century painter, suffered many such attacks, and because of them he never displayed his more adventurous art to the public during his lifetime. He did not see any point in exposing these paintings to the critics of the day. Today anything goes. Bent tubing, slabs of steel and solid black canvasses are what life is about today—or so we are led to believe. I am definitely living in and clinging to the past, and I like it back there. I was born to draw, sketch, paint, to create and to share what I enjoy and care passionately about with anyone who might be interested.

———•—•—•———

How I love water! As far back as I can remember I have been amazed by this incredible substance. I'll never forget that day in school when the teacher pointed out that as water gets colder it sinks, but just before it reaches the temperature at which it freezes it expands, so ice forms on the surface rather than on the bottom of the lake. I was overwhelmed by that simple fact as the teacher continued to explain that in the northern hemisphere lakes would freeze solid and remain that way if it were not for this characteristic. This fact, as well as many others that I learned in science, convinced me that God really knew what He was doing when He created the Earth. Another thing that impressed me is the amount of water covering the Earth's surface. In recent years I have come to believe the perceived abundance of water is the reason we treat it so badly. As an artist, water has never failed to fascinate me, and it is the subject of most of my films and many of my paintings. Water is a chameleon, taking on the colour of its surroundings when it is calm. But let a breeze spring up and it becomes a kaleidoscope of colours, shapes and textures. Gravity is another force that affects water in wonderful ways. Plunging rapids and cascading falls are my favourite forms of water, but I also enjoy sharing the solitude and calm of quiet places hidden away in the Precambrian Shield, places where people seldom go.

SWAMPS

PRECAMBRIAN REFLECTIONS 6 x 4⅞ inches

WHAT YOU DO TO make a living determines how you see. The geologist focuses his attention on the rock. The hunter looks for movement in the trees and grass or searches for tracks or broken branches. The photographer seeks out compositions within the scene. Some people look at a scene and see scenery. They enjoy the scene before them as a whole. The painter looks at every detail contained within the scene and then begins to select what he wants for his painting. When confronted with a scene, I can look at it from a distance or I can walk into it and examine the minute details that make the scene what it is. Years ago I discovered quite by accident that it was possible to do the same with many of my paintings. Using a magnifying glass or a camera close-up lens, one can explore my paintings and find colours and compositions within each painting. With most painting techniques, close examination usually reveals brush or palette-knife strokes. But with my paintings, close examination does not reveal how the paint was applied, there are no brush strokes. A small section of this painting is detailed on the following page. In *Precambrian Reflections* the rock and trees are little more than an excuse to have some fun with reflections on the surface of the water. A light breeze disturbs the surface ever so slightly. The colours, textures and patterns change constantly and are never the same. I didn't do this painting of any particular place, but it reminds me of a point of land in Lake of the Woods.

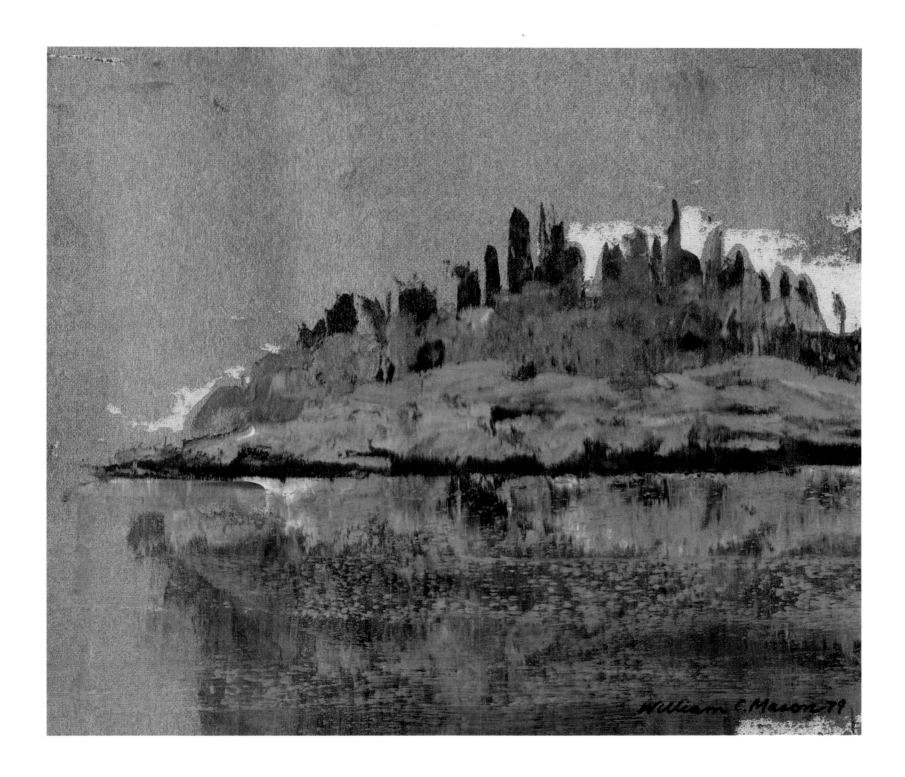

PRECAMBRIAN REFLECTIONS detail

THIS DETAIL SHOWS A small section from the previous painting. It was blown up from an area of two by three inches. The closer I move in on the painting the more impressionistic it becomes. By isolating smaller areas of the painting I am doing what the photographer would do with the use of telephoto lenses as he stands before a scene.

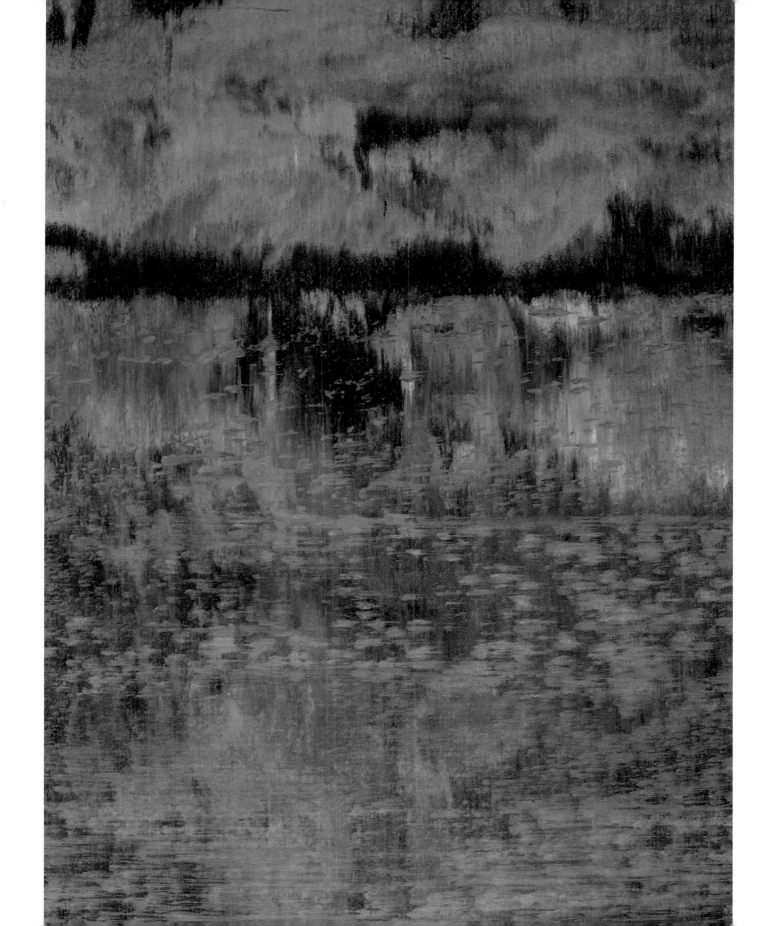

WINDLESS DAY 11 x 10 inches

THIS PAINTING IS LITTLE more than a suggestion of how a windless day in a swamp feels to me. Sometimes it's hard to tell where rock ends and water begins. The lack of sharpness in the overall picture leaves something to the imagination of the viewer. The slightest disturbance of the water breaks the reflections into the most fascinating impressionistic patterns.

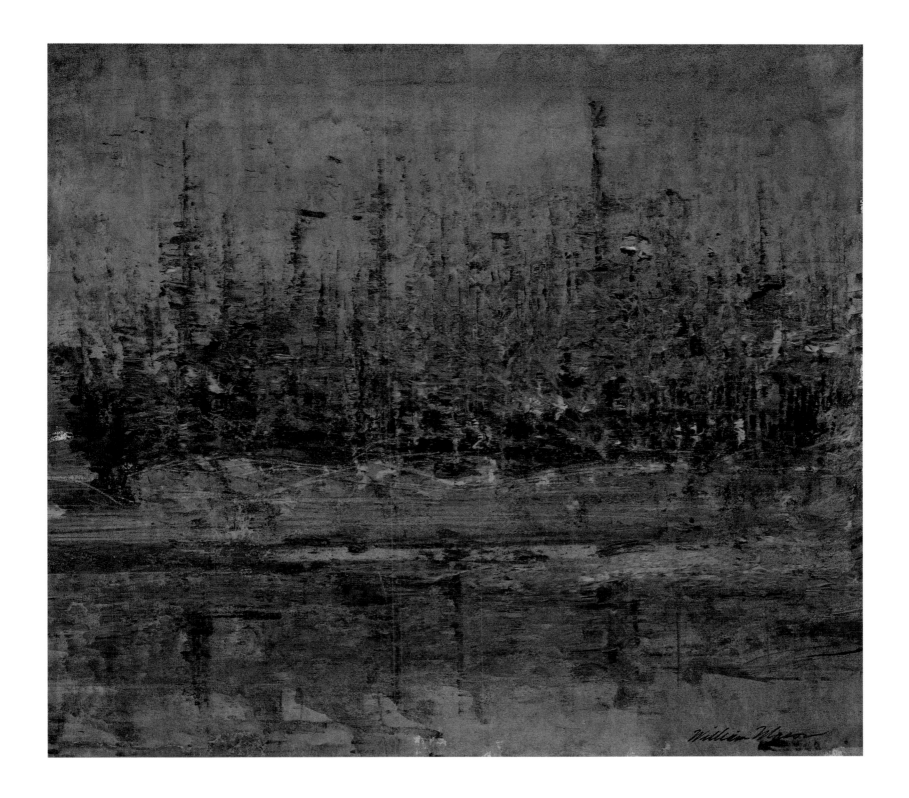

SWAMP STUMP REFLECTION 7 x 10 inches

SOME SWAMPS OR PONDS are the result of beaver activity. The creek behind our house has five different ponds. The beavers move from pond to pond as the food supply diminishes. This allows the trees to grow back. It's a form of sustained yield utilization of the land, something that most human beings have been unable to put into practice. As a result, the forests around the world are disappearing at an ever-increasing rate. It always fascinates me that the animal kingdom seems designed in such a way that eventually everything balances out for the well-being of all. We have so much to learn from observation of the natural world.

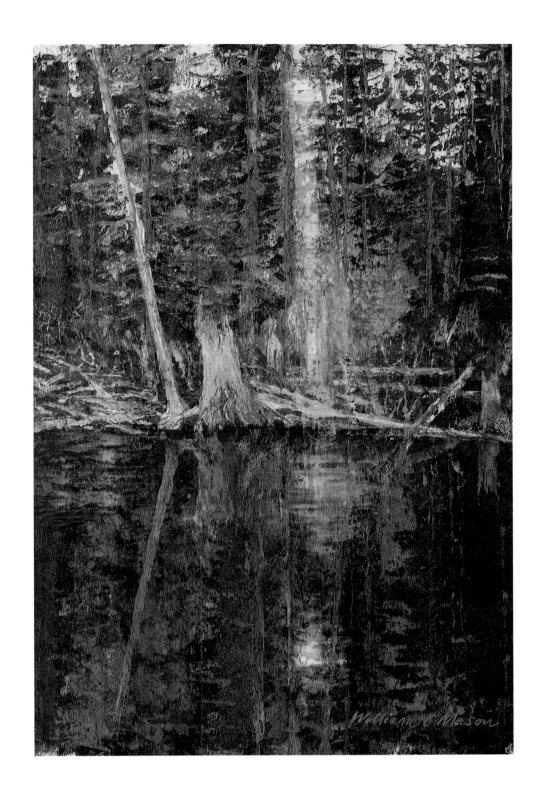

BEAVER LODGE SWAMP, PUKASKWA HEADWATERS 12 x 10 inches

IN A BEAVER SWAMP you are mainly aware of death. But this is only an illusion. The swamp actually supports life, not only in and around the swamp, but downstream as well, as water is slowly leaked into the drainage system over the long, hot summer.

The beaver lodge is an amazing structure. It is an impenetrable fortress made from sticks and mud, with an underwater entrance. To break into it you would have to remove the sticks one by one in the same order in which the beaver built it. Painting a beaver lodge presents an interesting challenge. The lacework patterns formed by the dead trees are so intricate that one can only hope to create an illusion of the tangled growth.

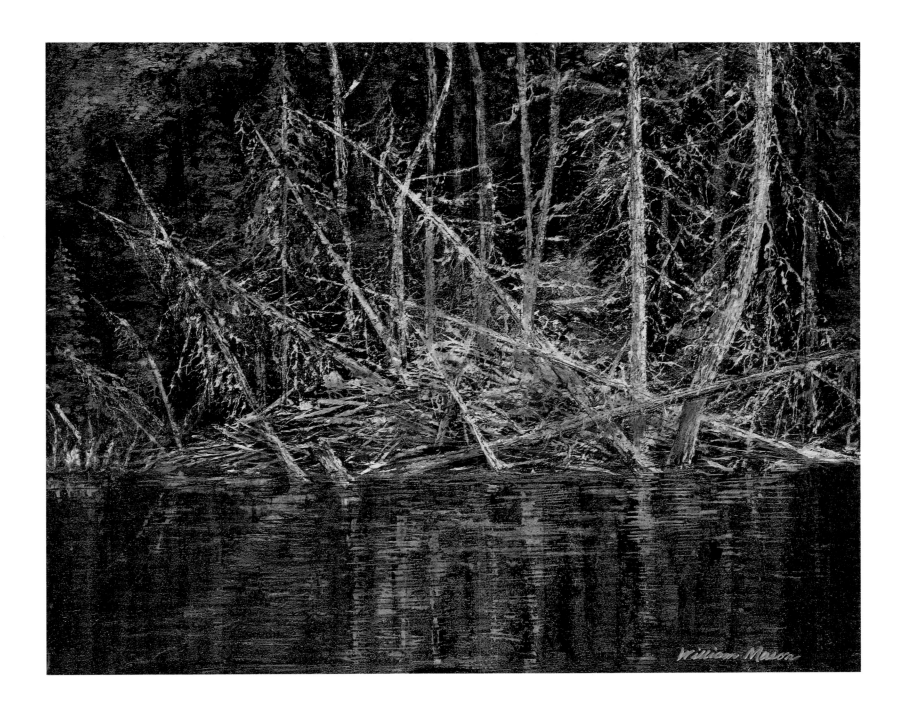

LILY PAD SWAMP IN MIST, PUKASKWA HEADWATERS 12 x 10 inches

THOUSANDS OF YEARS AGO, glaciers scoured depressions in the landscape, and ever since the forces of nature have been filling them in, with varying degrees of success. This swamp is well on its way to becoming a meadow. The water lilies have almost completely covered the surface. The sun's rays have burned off the early morning mist. In complete contrast to the fast-flowing rivers and wave-washed shores of Superior, it's the quiet swamps where life abounds. But to see and hear it you must be still. That's what I like about painting, it forces me to be still, and for me that's not easy; I like to be on the move to see what's around the bend or over the next hill.

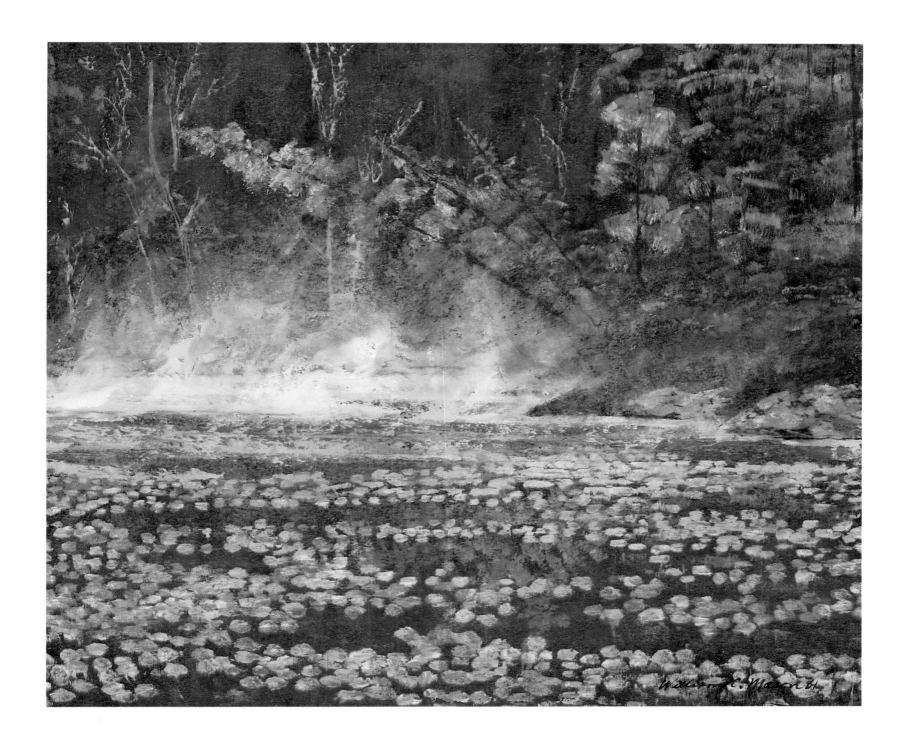

EDGE OF A GRASSY SWAMP, PUKASKWA HEADWATERS 12 x 10 inches

THIS SWAMP AT THE headwaters of the Pukaskwa River, north of Lake Superior, has lost the battle with the forces of nature and is nearly completely filled in. Now there is water in it only in the spring or after a heavy rainstorm. Someday it will be as heavily treed as the forest at its edge. I am pleased with the feeling of depth as we look into the dark forest behind the tree. The surface of the original painting is as flat as this page and yet has a three-dimensional feel to it.

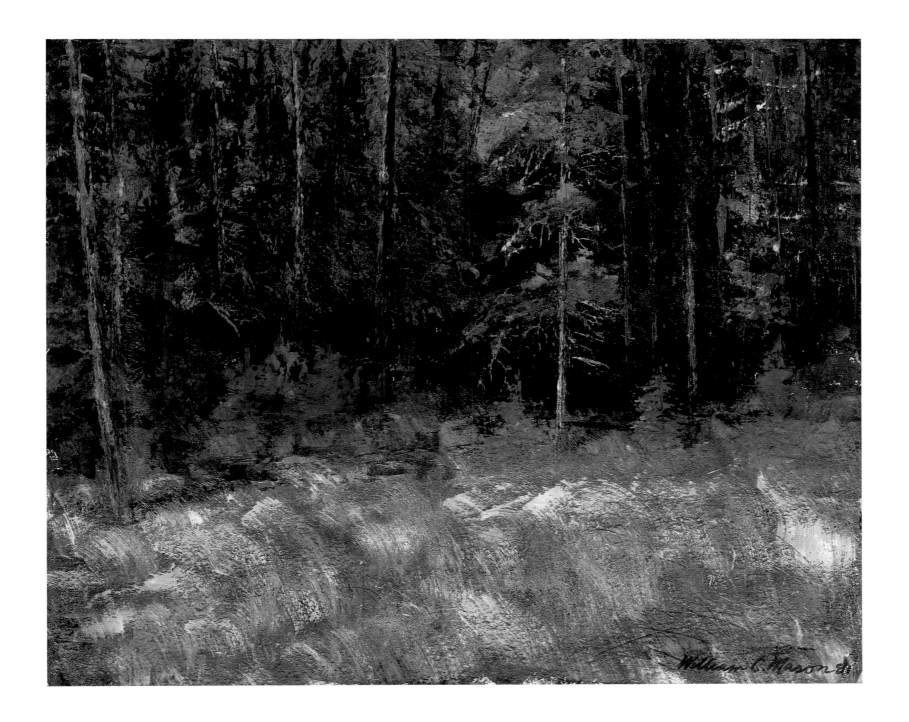

SHORELINE IMPRESSIONS

MORNING ON LAKE OF THE WOODS 6 x 3¾ inches

THE MORNING MISTS THAT envelope the islands of Lake of the Woods hold special meaning to me. As a camper at Pioneer Camp, I enjoyed our morning dip off what was called Senior Point. The air was cold but the water felt warm, clean and inviting. After my swim I would wrap up in a towel and watch the swirling mists between the distant islands. Sometimes, when the islands were obscured, I would be looking into a great void. On clear days there was only a watery horizon between the islands, because the lake beyond was so large. It was called Shoal Lake. The islands lost some of their mystery for me the first time we pointed our bow between them to head out into the lake on a canoe trip. In subsequent years, after I had become a counsellor, I led many trips of enthusiastic young boys out beyond the islands and further afield. It has always been a great thrill to share my love of the canoe and the land with young people. In this simple little painting I have tried to recapture the mystery that these misty isles held for me when I was a boy.

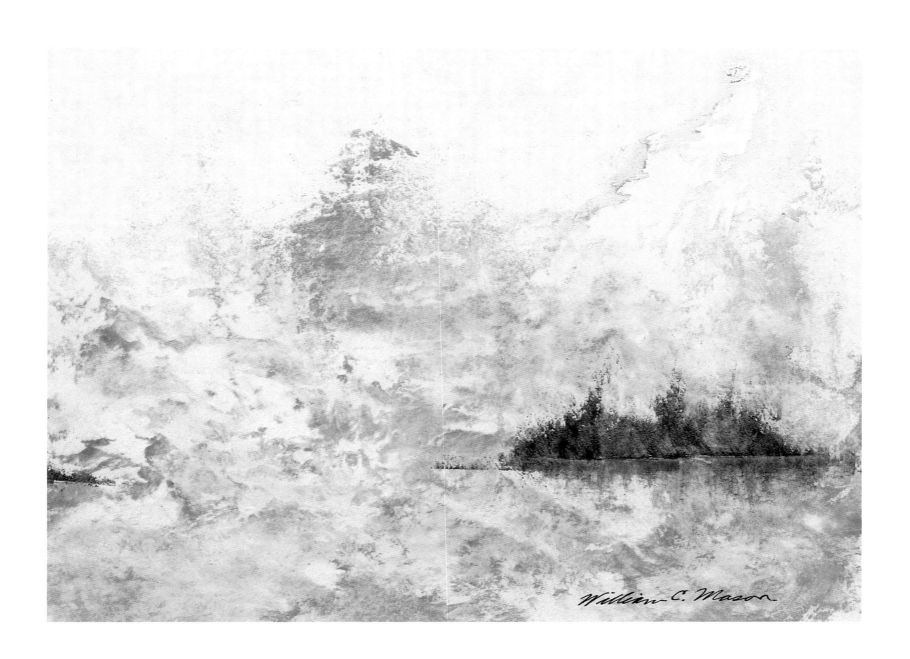

William C. Mason

GEORGIAN BAY SHORELINE, BYNG INLET 6 x 3⅝ inches

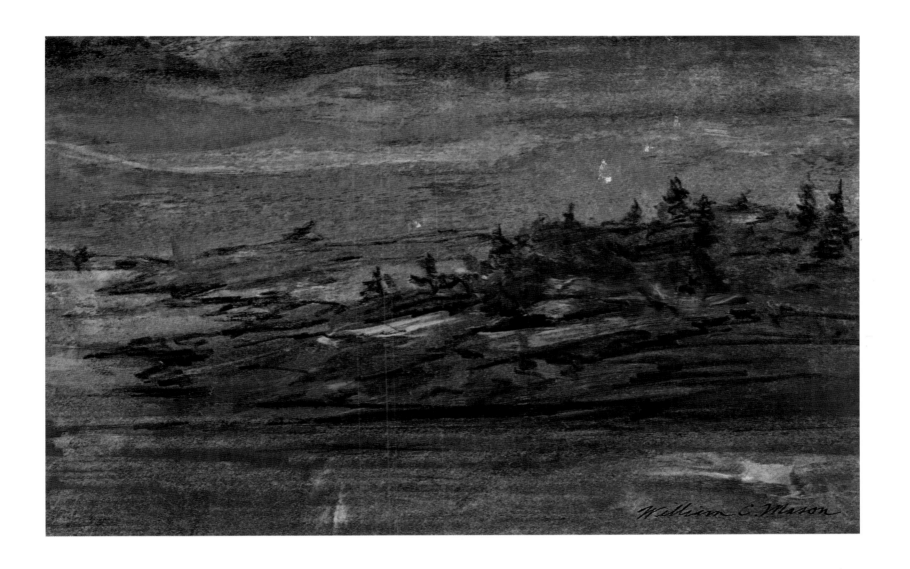

OLD WOMAN BAY, MORNING MIST 6 x 4¾ inches

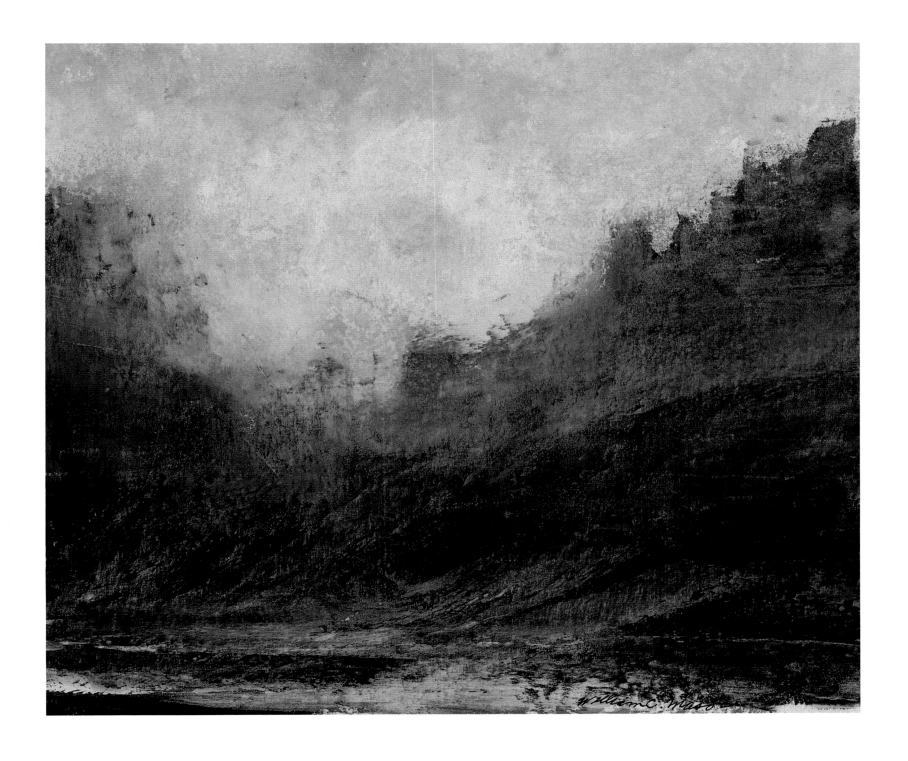

ALGONQUIN MIST 10¼ x 6¼ inches

I WOULD LIKE TO say that this painting was done on location, but it wasn't. Over the years, in my travels as a film-maker, photographer and painter, I have stored up thousands, maybe millions of images in my mind. Occasionally I will be painting in my studio, experimenting with colours and textures, when suddenly one of these images will be called up and the painting will fall into place. Many years ago I was paddling in the early morning on Opeongo Lake when I looked between two points and saw the last of the morning mist lifting off this quiet little bay. It beckoned me to come and explore it. This painting is much the way I remember the scene.

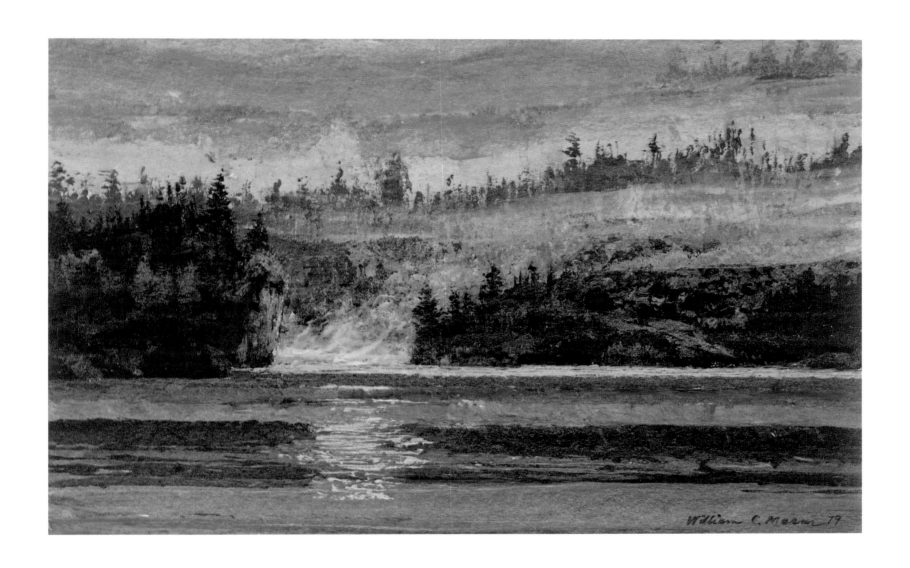

PINNACLE ROCK IN MIST, DEVIL'S WAREHOUSE ISLAND, LAKE SUPERIOR $3\frac{1}{4}$ x $4\frac{1}{4}$ inches

THERE IS AN ISLAND off Gargantua Harbour in Lake Superior with the ominous name of Devil's Warehouse. The island has a huge conical cave in the rock and several smaller caves higher up on the cliff. At one end of the island there is a pinnacle of rock that is slowly breaking away from the cliff face. I made several attempts at painting the pinnacle, but each attempt lacked feeling. To me this island is a strange and wonderful place, but my paintings did not portray my feeling for it. Finally I imagined the island bathed in swirling mists and ended up with this painting. I was intrigued by the name Devil's Warehouse. No doubt this name was given to the island by the voyageurs. They were a superstitious lot and inclined to attribute any strange or unusual land forms to the devil. In stark contrast, the native peoples tended to think of these same places as having special spiritual qualities. Not far from Devil's Warehouse Island, another island bears a startling resemblance to a chair. The white man calls it Devil's Chair Island. The native peoples regard it as the chair from which the Creator or Great Spirit created the world. Their attitude to things natural suggests that they had a more harmonious relationship with the natural world than did some of those who were strongly influenced by the church.

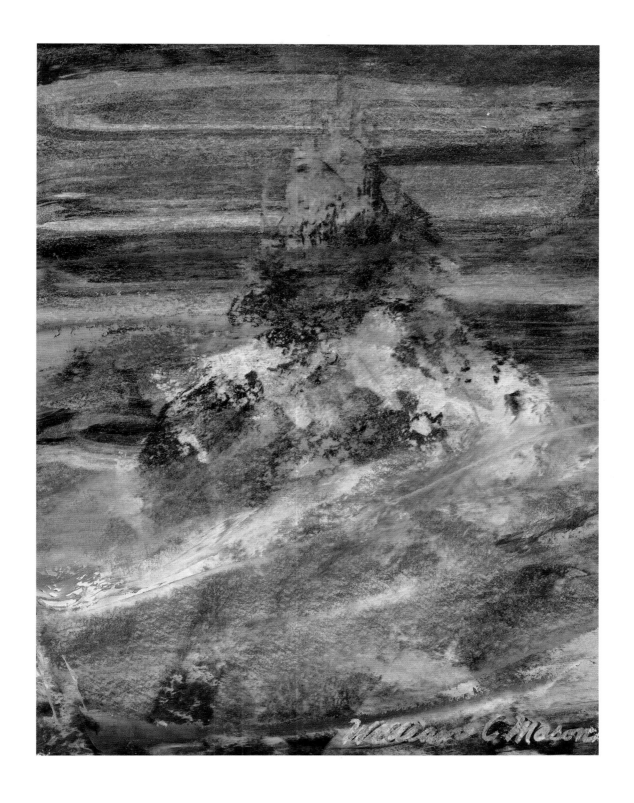

OFFSHORE SUNRISE, SUPERIOR 9½ x 6½ inches

THE VORTEX-LIKE COMPOSITION of this painting was definitely influenced by my favourite painter. I am sure every painter has a painter hero whom he worships. Mine is William Mallord Turner, an eighteenth-century British painter. When most people think of Turner they think of ships against a sunset or a pastoral English landscape. In reality he pre-dated the French Impressionists and even the Expressionists. His wildest paintings of storms at sea or avalanches in the Swiss Alps would make the most adventurous paintings of today look tame by comparison. One of the things I envy about Turner is his single-mindedness. He lived to paint. He sketched compulsively, and everything around him was a potential subject. He developed a form of shorthand so he could capture the essence of a scene or activity in little more than an instant. My love of the adventure and excitement of seeing what's around the corner or over the next mountain or the view from the top greatly reduces my output. However it does affect what and how I paint when I do sit still. For most of my life, I have painted scenes devoid of human presence. It seemed to me that a boat, car, train or building would be an intrusion. And yet my hero, Turner, populated his paintings with people, great cities, castles and ships—most of all ships. And many of them in their death throes as they were dashed to pieces on the rocks. He was fascinated by the violence of storms at sea when people were at the mercy of the elements. Turner created endless paintings of people whose lives were hanging by a thread as they attempted to make shore in their frail lifeboats, or as they were about to be swallowed up in an avalanche. Turner sometimes purposely exposed himself to great danger. One of my favourite stories recounts an adventure at sea. At the height of a great storm, Turner had the sailors lash him to the mast so he could stay on deck and witness the full fury of the gale. He had some doubt the ship would survive the storm. It is this event that shows up again and again in his paintings. I imagine that as the years passed Turner embellished and exaggerated the fury of the storm. I do it all the time in recounting my experiences swimming the rapids of northern rivers!

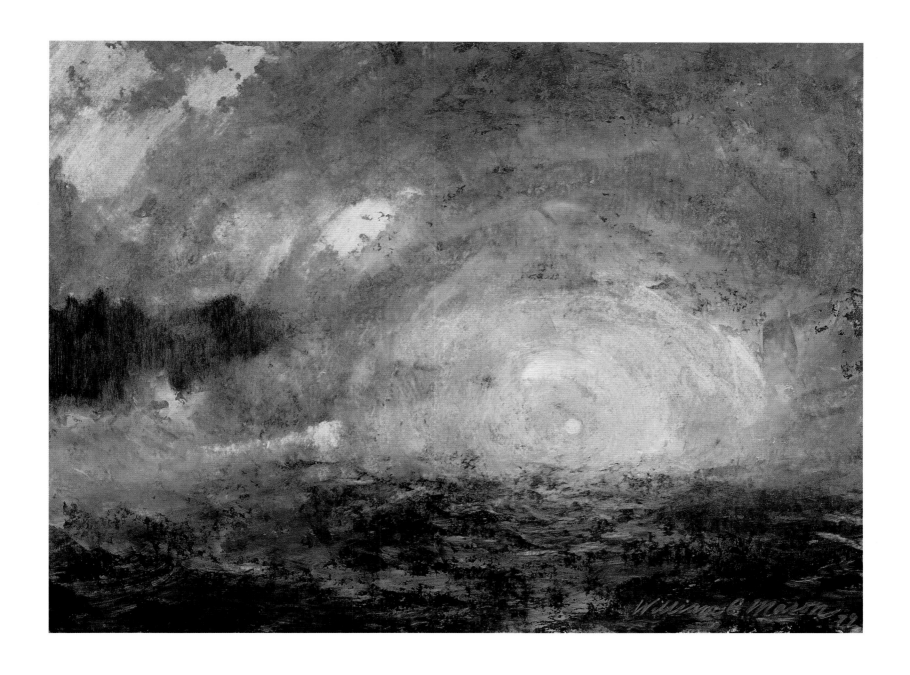

NORTHERN LIGHTS AND SPRUCES 6 x 8 inches

SOMETIMES I ENVY EARLY eighteenth-century painters like Turner and the subjects they had to paint, such as sailing ships at anchor in a picturesque harbour or castles perched on mountaintops. And then I think of our north country, with its canyons, falls, cliffs and trees, and I don't feel so badly. But sometimes when I look at those towering spruces I can't help seeing masts and yard arms against the night sky. I wonder if Turner ever saw the northern lights?

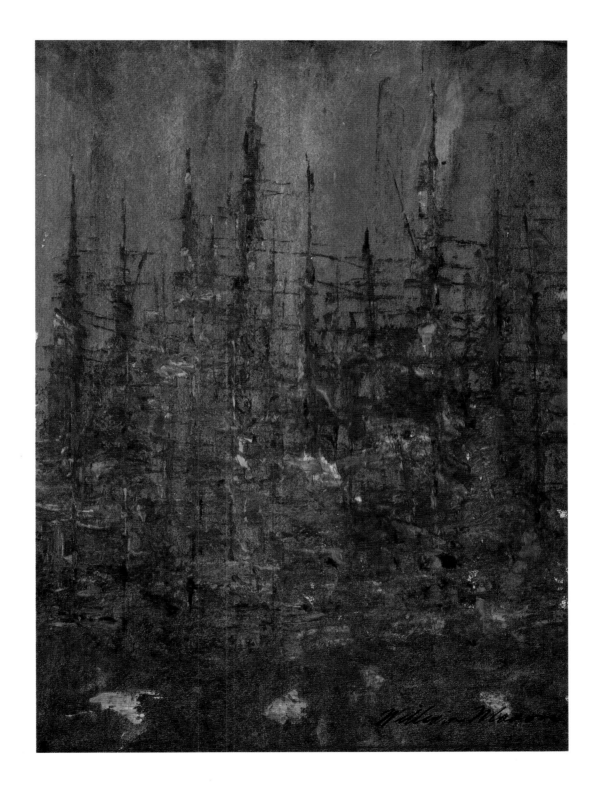

SUNDOGS AND SPRUCES 2 ½ x 2 ½ inches

I AM RELUCTANT TO reveal the size of many of my paintings. Some of them would get lost in the palm of your hand. One of my unframed favourites disappeared a while ago, and I suspect it got sucked up in the vacuum cleaner! It was only an inch across. There are several reasons why some of them are so small. They often grow out of an experiment beside a large painting I am working on. So I often experiment with colour on a small piece of paper to see if it's what I want. Occasionally I'll see a texture and shape emerging that reminds me of a place, so I finish the experiment as a miniature painting. There is a freshness and spontaneity in these little paintings that is sometimes lacking in my full-size ones, though even they aren't all that large, averaging eleven by fourteen inches. My palette knife technique is interesting in that the reproductions seen here provide no clues as to the size of the original paintings. There is another reason why many of the paintings are very small. Sometimes a painting is coming along very nicely when I mess up an area. Rather than throw the whole painting away I sometimes try to salvage an interesting part of it. Some of my best works arrive this way. The viewer will never know what's missing.

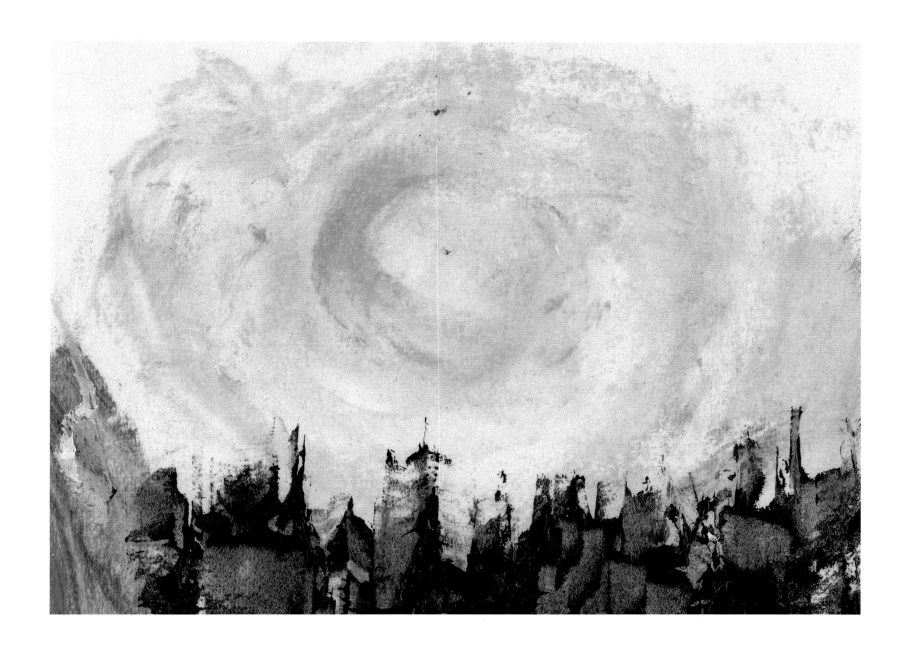

SPRUCE FOREST REFLECTIONS $4\frac{3}{4}$ x $12\frac{3}{4}$ inches

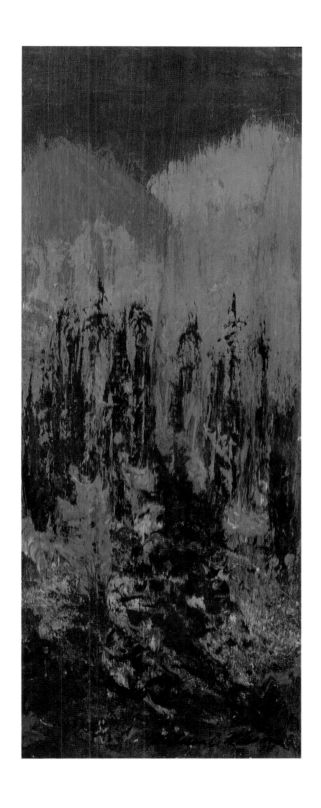

GEORGIAN BAY EVENING 3¾ x 2¾ inches

IT'S FIVE O'CLOCK AND nothing has worked today. I have a wastepaper basket full of paper loaded with paint. The palette is a mass of mixed colours. There's probably about fifty dollars worth of paint left on it. I am about to give up. I might as well scrape it off and call it a day. But it's tough to just chuck it. I grab a small scrap of paper, pick up a palette knife full of paint and smear it on the paper. I study it. The stroke is full of colours but they are strangely harmonious. I've seen that sort of thing somewhere; it's a sky in the evening after a stormy day. It needs a setting sun, but just a suggestion burning through the cloud cover. It works. Where did I see that sun and sky? Then I remember. Georgian Bay. I need some low, rocky islands. But instead of painting the islands themselves, I grab a daub of greenish blue and shove it around until it becomes trees and the shadows of the rocky islands. I define where rock ends and water begins. I clean the palette knife and go back to the mess of yellow I used for the sun and add a reflection. Now a bit of scraping on the surface of the water, not too much. I step back and know I've got it. There's a feeling of time and place, and that's exactly how it felt. It was a good place to be. After slaving all day and producing nothing, this memory of a time and place comes forth out of the chaos of my palette in just fifteen minutes. It is a good day. Better than most.

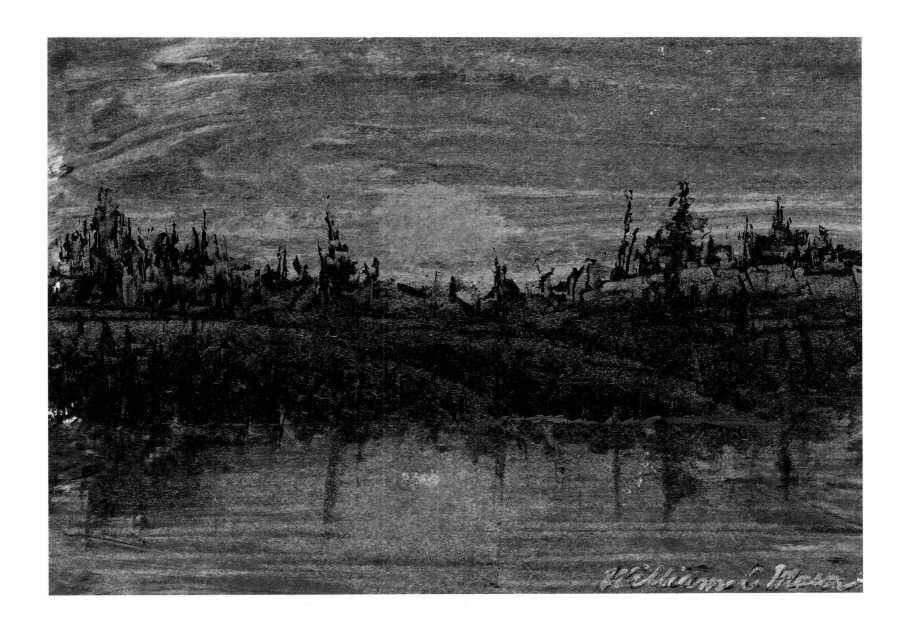

MINIATURES

I *MOUNTAIN NEAR ROGER'S PASS* 3 x 2 inches.
II *THE SLEEPING GIANT, LAKE SUPERIOR* $4\frac{1}{2}$ x $2\frac{1}{4}$ inches
III *FALLS ON THE SAND RIVER, LAKE SUPERIOR* $4\frac{1}{4}$ x $3\frac{1}{2}$ inches
IV *A WHITE PINE STUDY* $1\frac{5}{8}$ x 3 inches

A PAGE OF MINIATURES reproduced in their actual size, followed by several pages of enlargements, gives some idea of the interesting things, barely discernible to the naked eye, that happen within these paintings. The original paintings should be scrutinized through a magnifying glass to really enjoy what's there. However, a reproduction cannot be viewed this way because the dots of ink from the printing process become visible. For this reason the miniatures were enlarged photographically before being printed on the following pages. Most paintings come together and look better when viewed from a distance. My paintings are the exact opposite. They do make sense when viewed from afar, but I think they take on more meaning and reveal more upon closer inspection. Although I discovered my method of painting accidentally, I like it, because my paintings are enjoyed the same way nature is enjoyed—the amount you see depends on the effort you put into your observations.

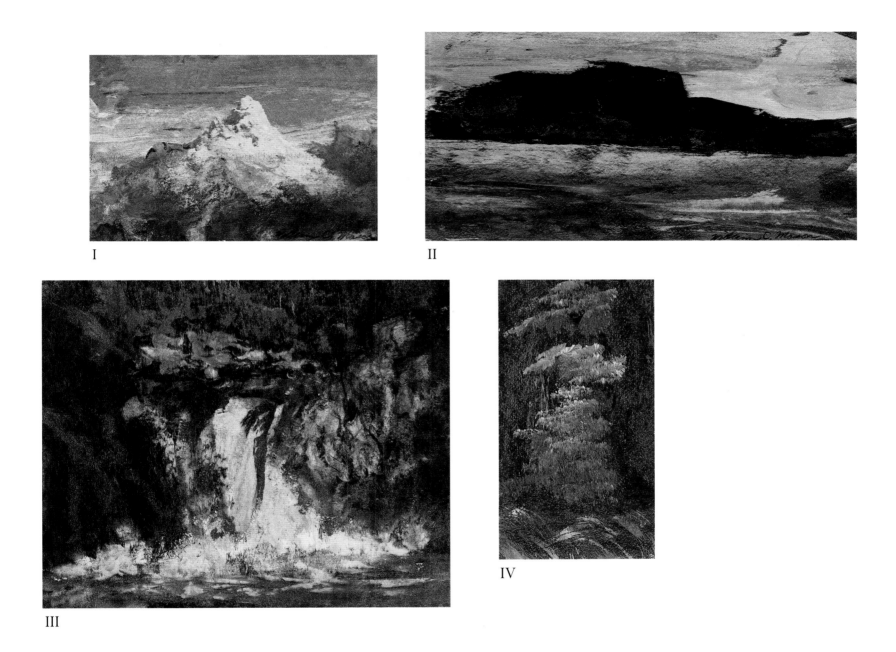

I

II

III

IV

MOUNTAIN NEAR ROGER'S PASS detail

I HAD SKIED FOR a day to reach a hut, then climbed for most of the second day on my telemark skis to reach a saddle that looked out across a deep valley. Beyond lay this mountain at the base of Roger's Pass. I have no photographs and no sketches of this mountain. The painting arrived out of nowhere as I experimented with my palette knife. In this enlargement much is left to the imaginative eye. There is much more to look at than in the original miniature on the previous page.

Telemark skiing presents a problem. I enjoy the thrill and challenge of cross-country and telemark skiing so much that it cuts into my painting time. I should have been sitting on the saddle sketching and painting among the peaks. Instead I spent a riotous day of telemarking with my friends. I often envy Turner's single-mindedness of purpose. However, I'm sure I have had a lot more fun than he did!

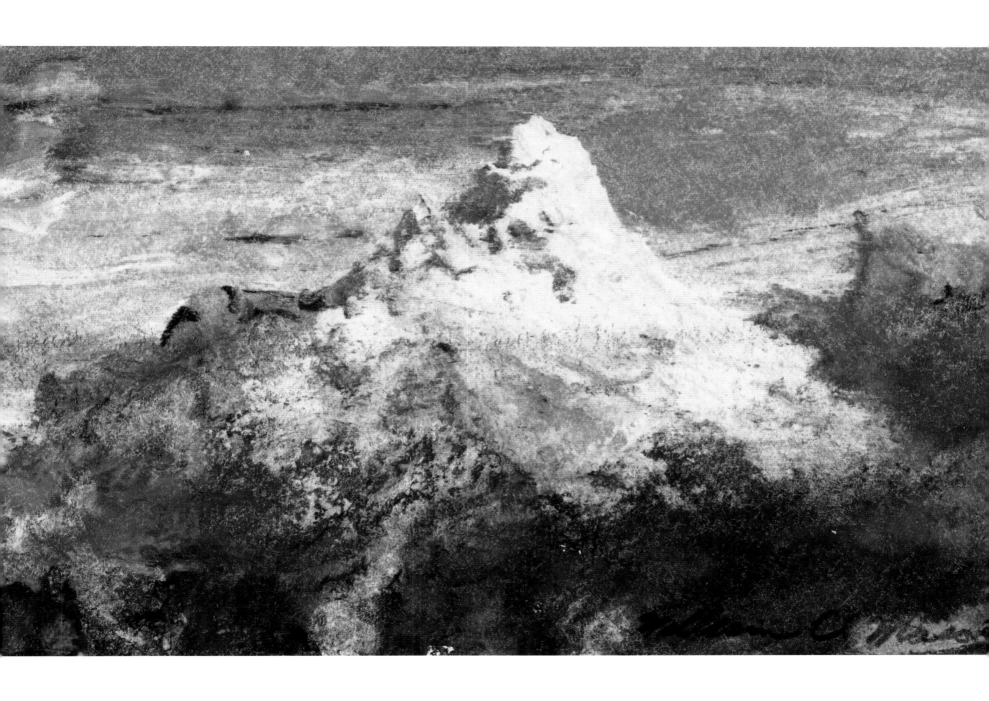

THE SLEEPING GIANT, LAKE SUPERIOR detail

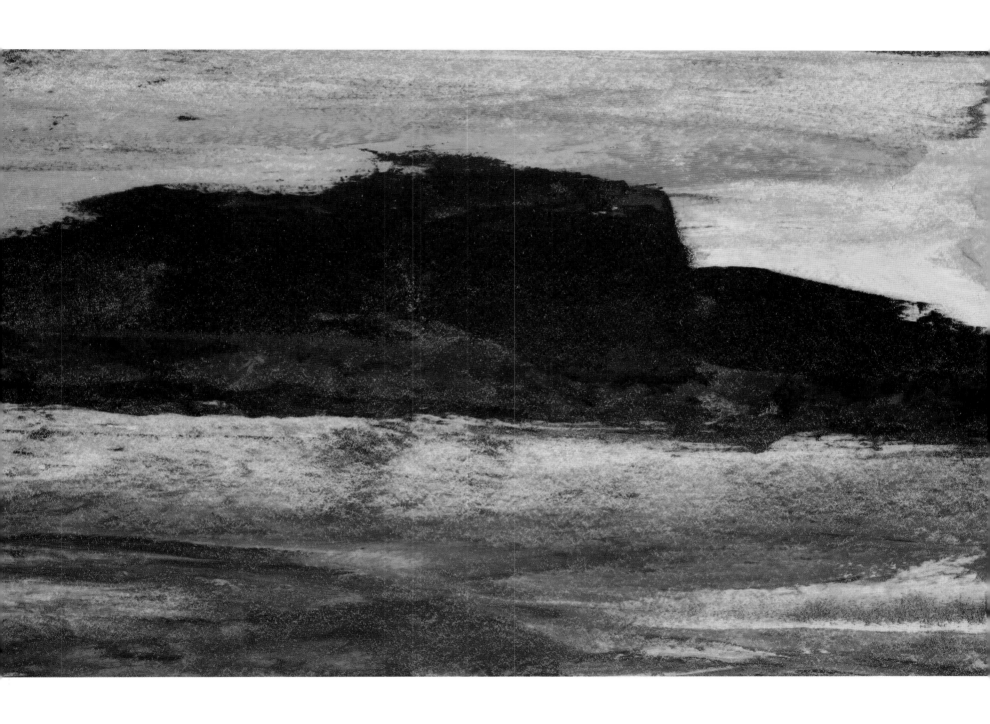

FALLS ON THE SAND RIVER, LAKE SUPERIOR detail

WATERFALLS ARE BECOMING ENDANGERED. The juggernaut of mankind rolls across the face of the earth even in the most remote wilderness. I wonder if we are any happier than the native people who lived and died here without changing the land.

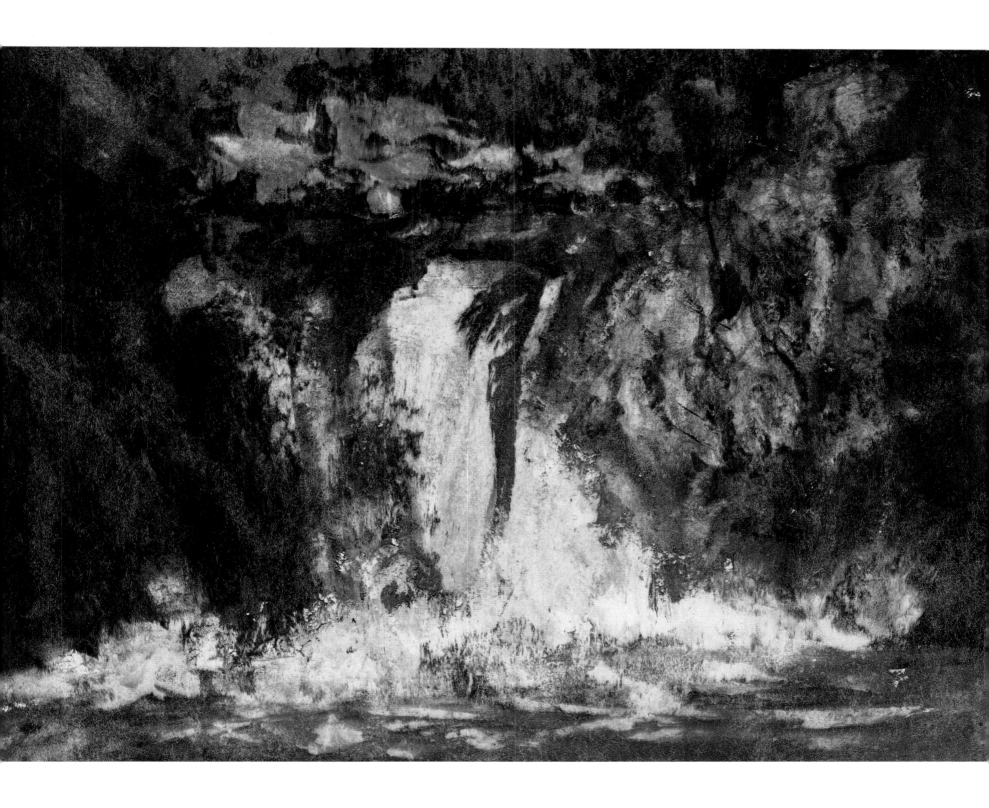

A WHITE PINE STUDY detail

I ENJOY PANORAMIC SCENES but sometimes I like to move in to capture the essence of a single subject, such as a clump of grass or a tree. The original of this painting is very small, as can be seen on page 51. This enlarged reproduction reveals more.

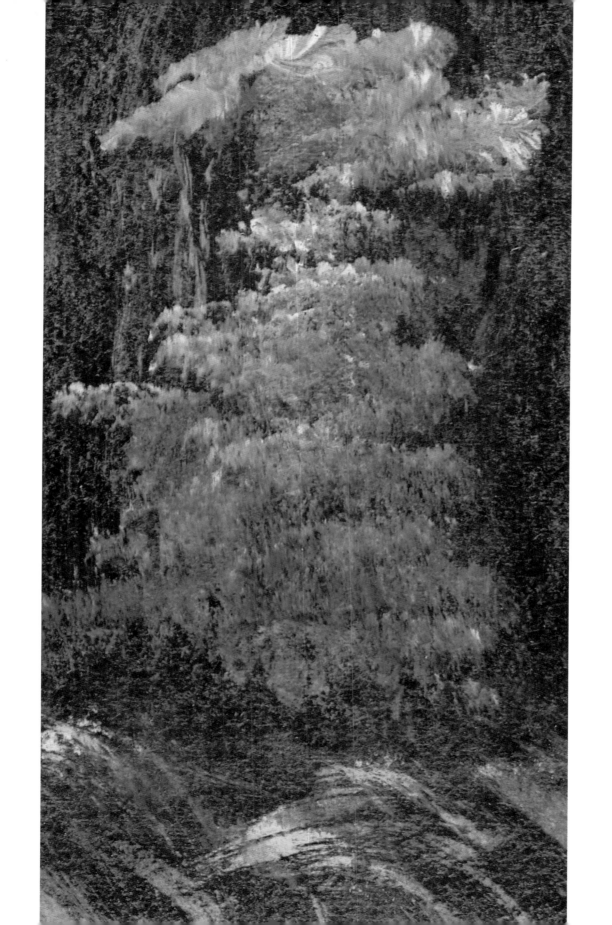

FROZEN SHORES

PRECAMBRIAN SHORE BEYOND THE MUSKEG 9⅝ x 6⅝ inches

AS THE PRECAMBRIAN SHIELD swings north it eventually leaves the spruces and birches behind. During the brief summer months the ground cover is wildflowers and lichens. When travelling overland it is a great luxury to be on rock but complete misery to be in muskeg. Because of the permafrost, there is nowhere for the water to go, and it sits in pools and slowly evaporates. When the sun shines, the temperature can be uncomfortably hot, bringing out hordes of mosquitoes. When the skies are dull and wind-blown, it can be very cold, even in summer. Despite all this, the Barren Lands have a strange beauty, and I forget the hardships and long to return. In this painting I have tried to capture the land as I remember it. It is not of a particular place. This is one of the very first paintings, if not the first painting, that I rendered in my oil-on-paper technique. Until then I had used the extremely thick impasto technique in an attempt to create a three-dimensional effect. Except for a few watercolours and pastels I have not painted any other way since, because the oil medium is so perfectly adapted to the portrayal of rocks and trees, rivers and lakes, wind and waves, and reflections in water. As I experimented I found that the new technique forced me to be far less concerned with detail. It was the overall effect that was important. A quick perusal reveals very little detail, but the viewer's imagination can search out its own meaning. This painting, with its cold, wind-blown sky, outcrops of pink Precambrian rock among the ground cover, and the vegetation-choked muskeg, has captured the frigid Arctic landscape better than anything else I have painted.

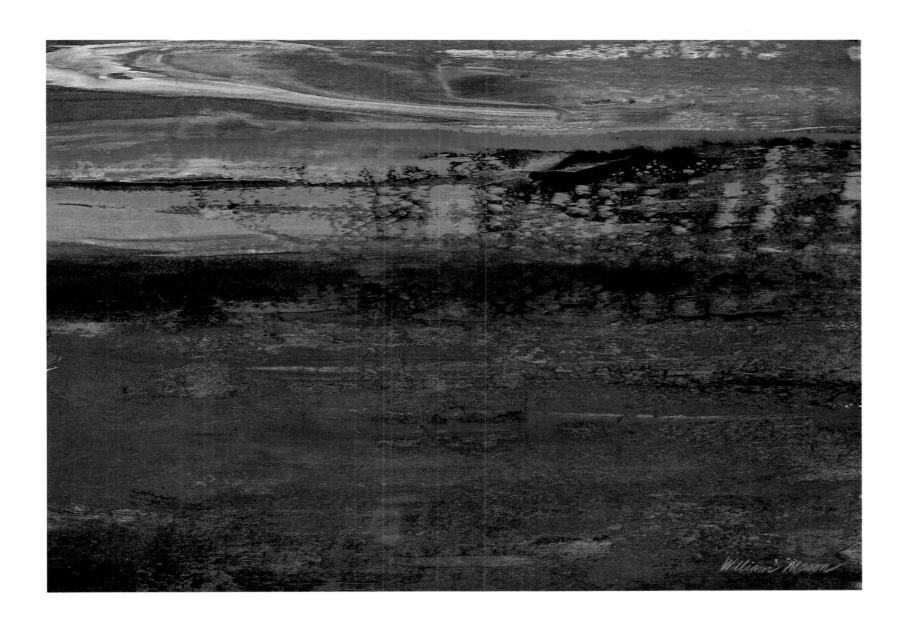

A COLD NORTHERN PANORAMA OF ARCTIC ISLANDS AND DISTANT HEADLANDS,
LANCASTER SOUND 11¾ x 5⅝ inches

THIS TITLE ALLOWS THE viewer to create his or her own painting. For those who have visited the Arctic, it should bring back memories. I was involved in filming the expedition to explore the remains of the *Breadalbane*, a ship that sank in Lancaster Sound during the search for Franklin. Bundled up in my warm clothing I imagined the *Erebus* and the *Terror*, Franklin's two sailing ships, working their way west in search of the Northwest Passage. They disappeared without a trace. Today, somewhere out there beneath the ice-choked waters, they are sitting on the bottom of the sea, probably perfectly preserved.

I was filming from the bridge of an icebreaker as we pushed our way through the ice heading for Beechey Island. It was a raw, damp, windy evening. There was just enough light to film the distant island and headlands. It was just about the coldest scene I have witnessed and it was what the early British sailors had faced nearly two hundred years ago. In four hours we had covered a distance that had taken those early explorers two years to cover. This painting is as I remember the scene from the bridge of the icebreaker. The cold finally penetrated my heavy winter clothing, so I opened the door into the warmth and comfort of the closed bridge as the purser arrived with his silver tray of coffee, tea and biscuits. As I sipped my tea and ate the biscuits, my thoughts dwelt on the contrast between today and 1850.

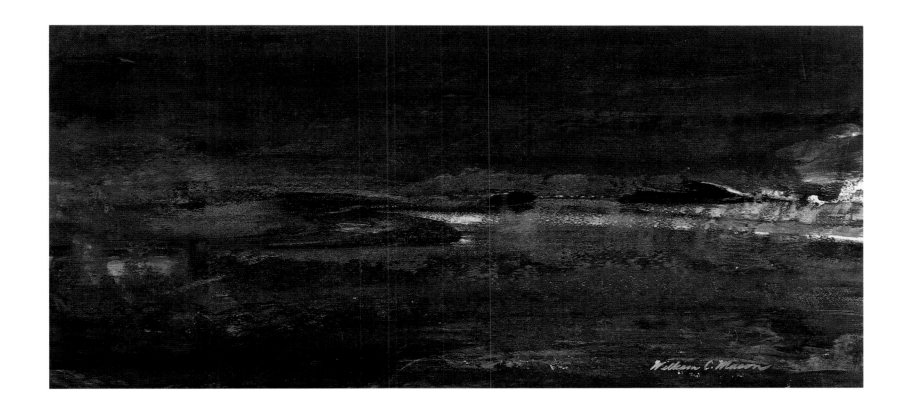

FREEZE-UP AFTER FIRST SNOW 9 x 7 inches

WHEN I PAINT I have a lot of time to think. I think about my subject and the various forces that caused it to be. When I paint frozen water I never cease to marvel at the design of the laws that govern its behaviour.

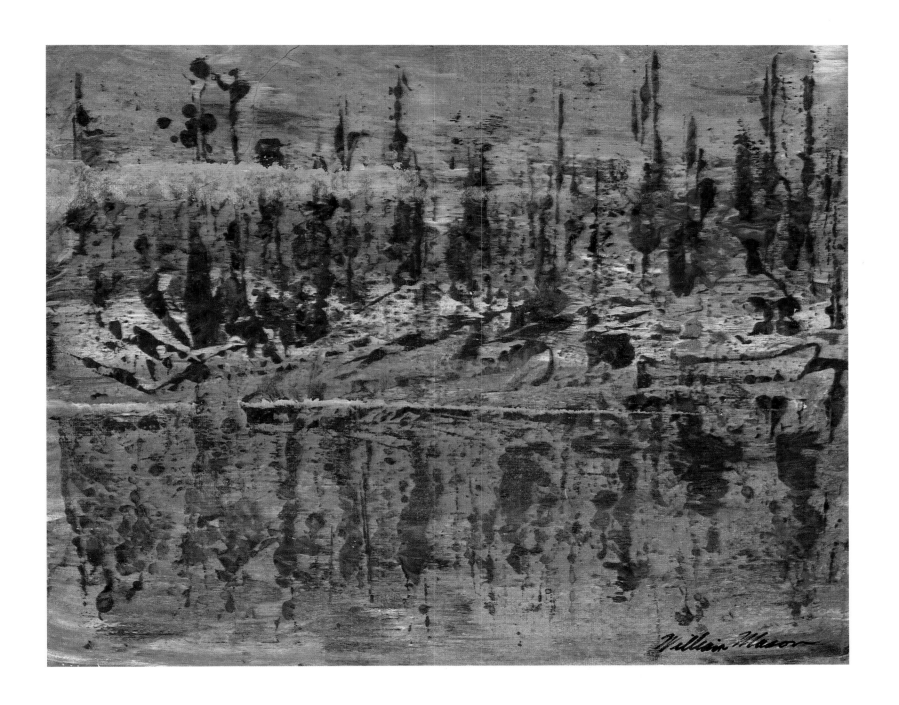

SWAMP IN FIRST SNOW $10\frac{7}{8}$ x 7 inches

ONE DAY I WAS experimenting with textures when all of a sudden spruce trees laden with soft, fresh snow emerged. I quickly repeated the texture with trees lying on the ground and then with a row of trees in the background. I remembered a scene just like this when I was filming on a pond north of Superior. Next I created a pondlike surface behind the row of trees in the foreground and then reflected the back row of trees in the still water. This was the pond that I used for the last sequence of my film *Waterwalker*, depicting my journey home as the lakes and rivers began to freeze over.

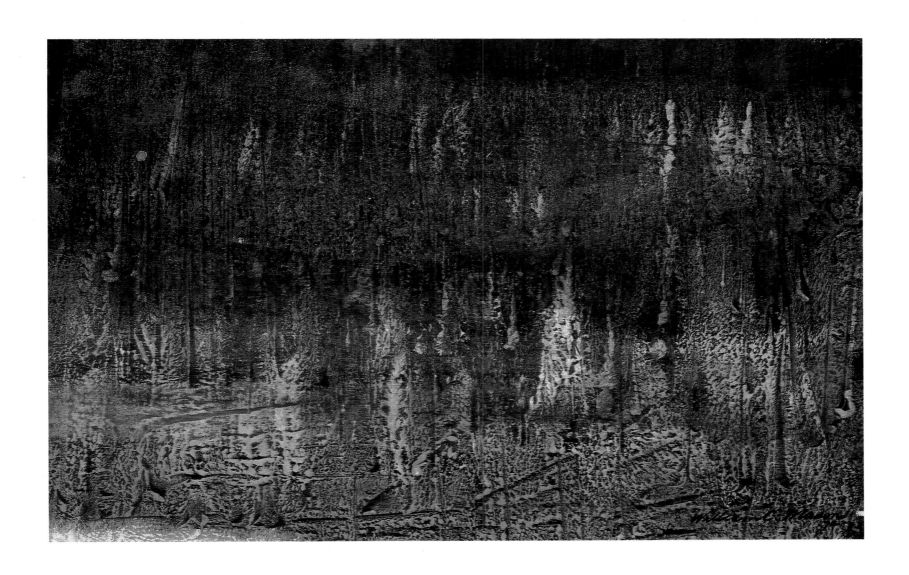

CLIFFS AND ROCKS

PUKASKWA RIVER CLIFFS 5 x 2¾ inches

I NEVER TIRE OF painting cliffs, because each one has so much individuality. They change constantly as light plays across their surfaces, highlighting various planes in light and shadow. The colours in the rock and the patterns created by the lichens are in themselves abstract paintings.

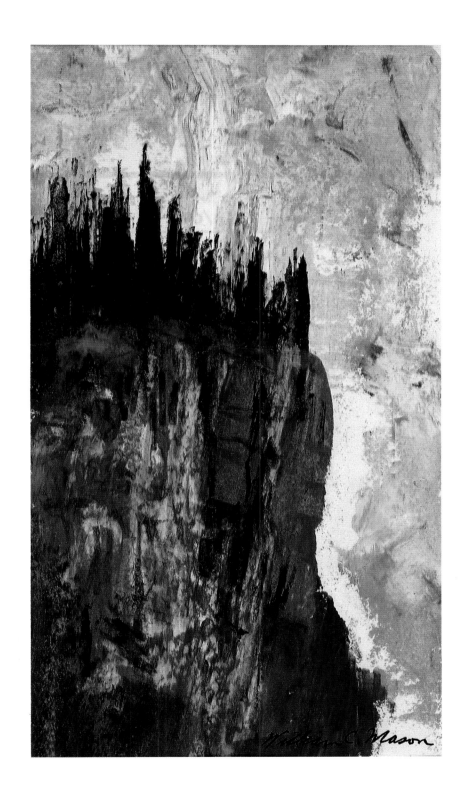

DUMOINE ROCK IN LIGHT AND SHADE 6¼ x 8 inches

I LOVE THE WAY light plays across a slab of rock and brings out the colours and textures, and the way the trunks of the birches stand out against a dark background. In the shadow of the cliff it's difficult to clearly discern what's happening with the jumble of rocks. The shapes and planes are only suggested. This painting was done from memories of the many times I have paddled through one of my favourite rapids beneath this cliff. I decided to leave the rapids out so I could concentrate on the rock and trees.

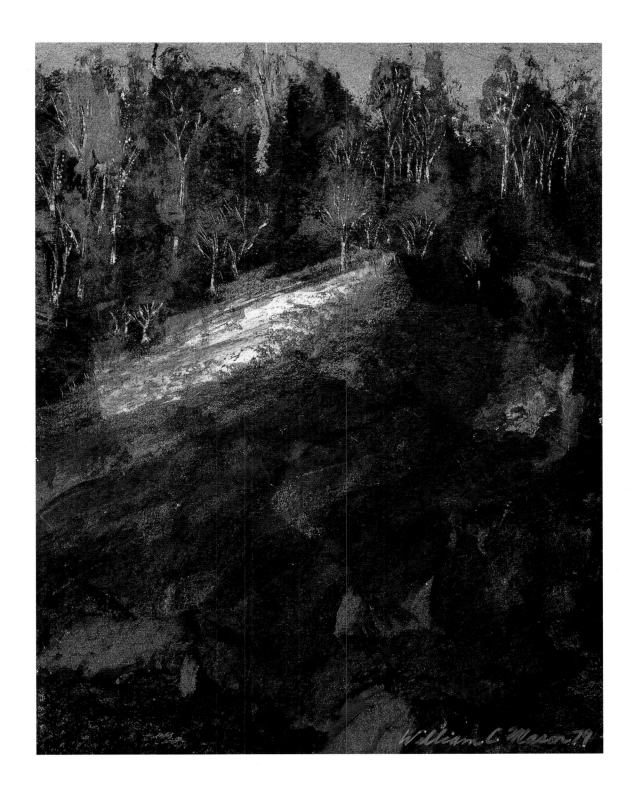

DRY TRIBUTARY OF THE NAHANNI RIVER $9\frac{1}{2}$ x $11\frac{3}{4}$ inches

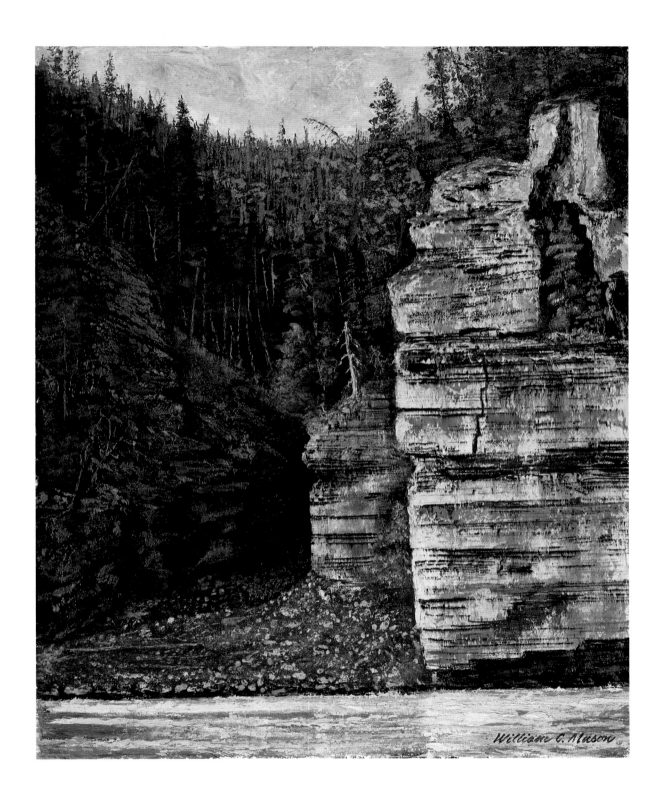

William C. Mason

ABSTRACT ROCK AND SPRUCE TREES 7½ x 4 inches

THIS SCENE WAS MEANT only to satisfy my urge to paint rocks. It could be any rocky shore along the waterways of our canoe country. To my surprise it came out resembling vaguely the colours and technique of a Cezanne painting.

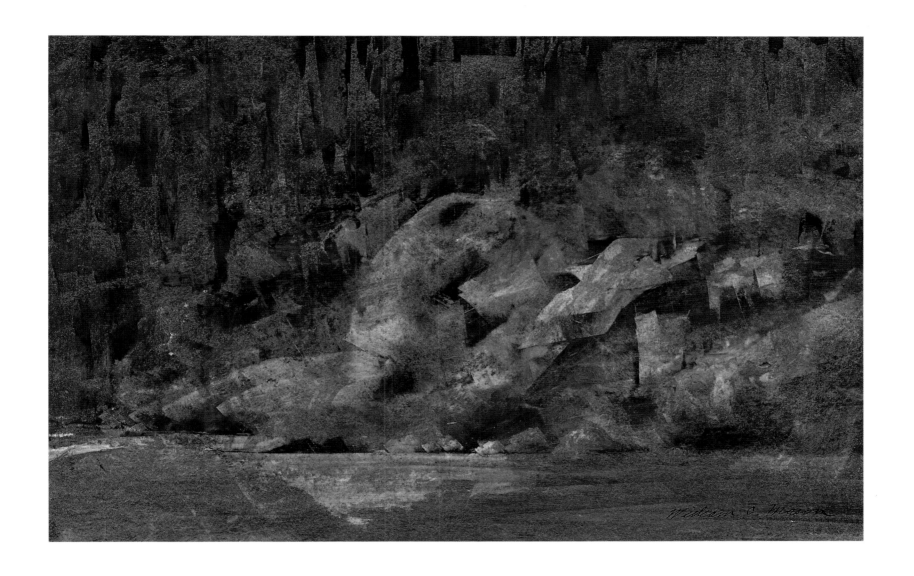

ROUNDING CAPE GARGANTUA IN A STIFFENING BREEZE $11\frac{5}{8}$ x $8\frac{5}{8}$ inches

THE GARGANTUA AREA OF Superior is a strange and wonderful place of rock pinnacles, caves, strange rock formations and sandy-bottomed inlets where you can walk for miles in water barely six inches deep. Rounding Cape Gargantua is always intimidating if there are waves. Once you set out you are committed to a nonstop paddle around the cape and down the shoreline to the safety of Gargantua Harbour, where you are rewarded with beautiful sandy beaches. In contrast to the exposed outer shores, the harbour is a warm, friendly place. The once busy fishing station is now shut down, but the road to it has been reopened to give people other than canoeists access. I preferred it when the road was closed, but I suppose it's selfish to want it all to myself. However, roads change things, and this road has changed the magical atmosphere of Gargantua Harbour.

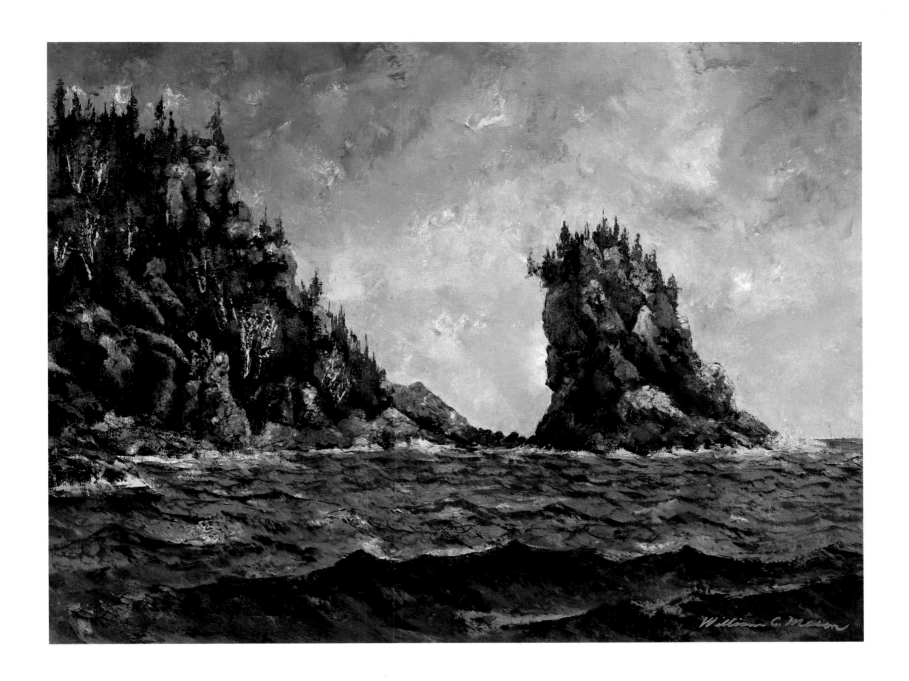

COVE NEAR DEVIL'S WAREHOUSE ISLAND, SUPERIOR 12 x 10 inches

THIS IS A STRANGE and wonderful place. The entrance to the cove is almost blocked by a huge rock. Trees have fallen over, bridging the gap between the two walls and creating a rooflike effect. In a storm, waves wash right into the cove, resulting in the smooth, rounded boulders. Directly behind me a cave in the wall goes back in to a depth of about twelve feet. To my right there is another entrance to the cove that opens out into Superior. On this hot day it was a wonderfully cool and comfortable place to sit and paint.

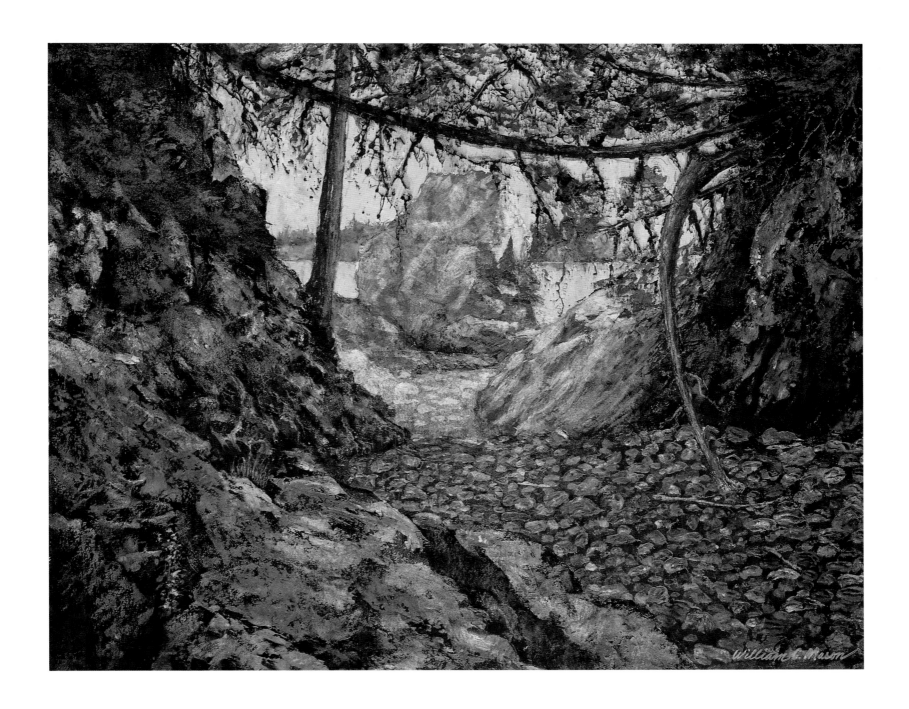

WAVE-WASHED ROCK $5\frac{3}{8}$ x $5\frac{3}{8}$ inches

ROCK FORMATIONS ARE ALWAYS fascinating for their shapes, composition, and structure, but also for their colours. To appreciate the colours found in rocks, they are best observed on a wet day. Or even better, on a day when the waves are washing up on the rocks, and you can lie there and watch the various colours sparkling and coming through the crystal-clear waters of Lake Superior. Some of the colours even seem to glow, they're so bright in contrast to the dark rocks. On many a windbound day on Superior, I have spent hours searching out these colours. I sometimes try to capture the feel of the rock in paint, but it's not an easy thing to do. The textures and colours are complex, but with the palette knife I can get a very complex-looking surface with one or two strokes. There are hardships in canoeing the rugged shores of a place like Superior, but for me, being windbound is not one of them.

STORMS

HIDDEN CREVICE FROM CANOE, SUPERIOR 7 x 9 inches

I HAVE BEEN CANOEING along the shores of Superior for twenty-nine years and delight in paddling in wind and waves. The lake is so large that the waves are like ocean swells. One danger is that a particularly large wave could break over you if you inadvertently paddled over a shoal. It only takes one wave to put you under. It's a risky but invigorating game. One thing about this game, you must always have an escape route if the waves begin to break. I paddle in large waves only when I know the area and have a cove to escape to. The crevice illustrated here is anything but a haven. I have passed many such places where the waves rush into the opening, sending spray high into the air as they hit the cliffs. It's an intimidating sight to look into the dark depths of a crevice when you're paddling along in waves. I like to watch the waves crashing and churning as they roll into the opening. You can't paddle too close because of the breaking waves and the backwash off the cliff face. This painting depicts just one of many such experiences.

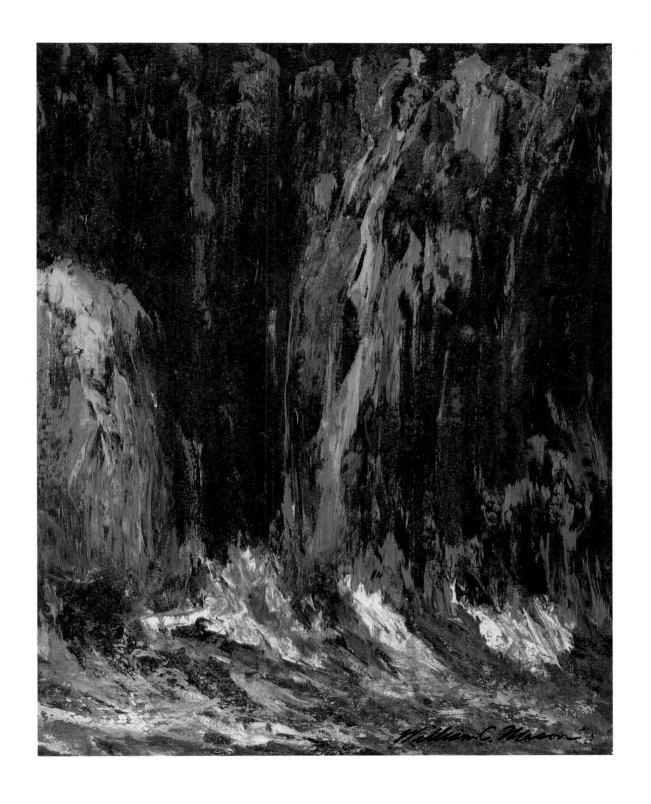

IMPENDING STORM, SUPERIOR 5¾ x 7¾ inches

BEING CAUGHT UNPREPARED BY an approaching storm is not much fun. Pitching the tent and securing both it and the canoe in driving rain can be quite a challenge. On the other hand, with the tent secured snugly behind a windbreak of trees or behind a rock face, the canoe tied down, a supply of firewood stashed under cover and the fireplace ready, an impending storm is a wonderful spectacle, especially if it's coming off Lake Superior. Wind-blown rain and waves crashing on rocks are among my favourite subjects. This painting combines my impressions of many impending storms.

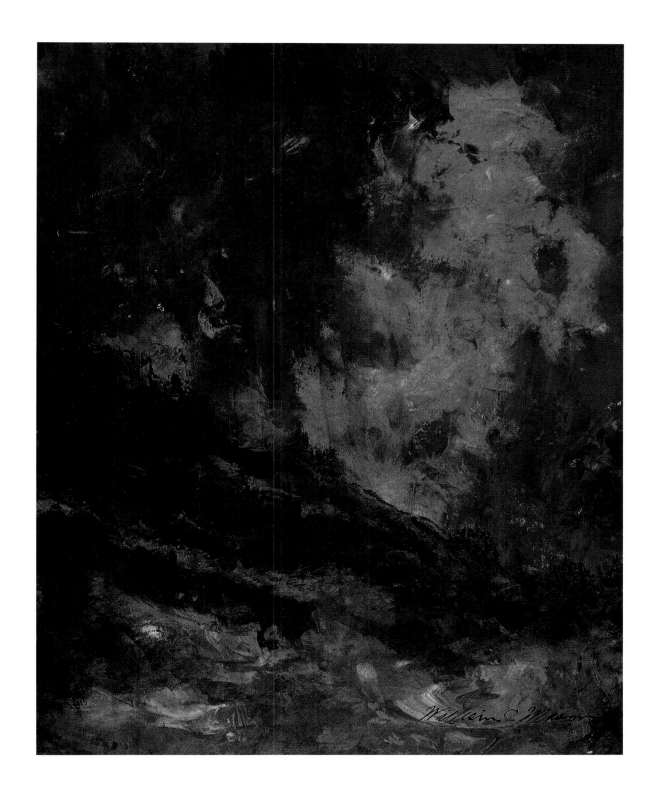

APPROACHING STORM, OLD WOMAN BAY, SUPERIOR 10⅞ x 13⅞ inches

I'VE GOT A THING about cliffs! I love everything about them—their colours, textures and patterns. I love to climb them and perch on their edge; the higher the better. I imagine diving from the top in a graceful swan dive and plunging into the water below. I would paddle for miles to reach a stretch of cliffs. Lake Superior is cliff country. Many of them extend for miles, making landing in a canoe difficult. They certainly add drama to the trip. Some of the most spectacular and easily accessible cliffs on Superior are at Old Woman Bay. They soar for eight hundred feet straight out of the water. They are fully exposed to Superior's storms, and waves have been known to send their spray as much as one third of the way up the cliff face—*that* I would like to see, but not from a boat! I'm sure that the spray went at least that high on the day the *Edmund Fitzgerald* went down with the loss of all hands. There really are only two kinds of boats that are safe on Lake Superior, an ocean-going ship large enough to weather any storm and a canoe or kayak that can be pulled up on shore when the going gets rough. Sailboats and powered craft have to find a cove or harbour in the event of a blow, and that isn't always possible. As you might expect, I prefer the canoe. A canoe can ride any size of wave as long as it isn't breaking. When the tops begin to curl it's time to go ashore. But it's got to be a lee shore. To fully experience the power and ferocity of the storm I have isolated a composition within the painting.

APPROACHING STORM, OLD WOMAN BAY, SUPERIOR detail

I WOULD LIKE TO blow this painting up to a height of ten feet to increase the sense of drama. I am often asked why I don't paint big. The answer is, I can't. With my technique it's not possible. In fact many of my best or most interesting paintings are only a couple of inches high. That's what is so wonderful about painting. I can do anything I like. It's my paper and my paints. Painting provides me with a great sense of freedom.

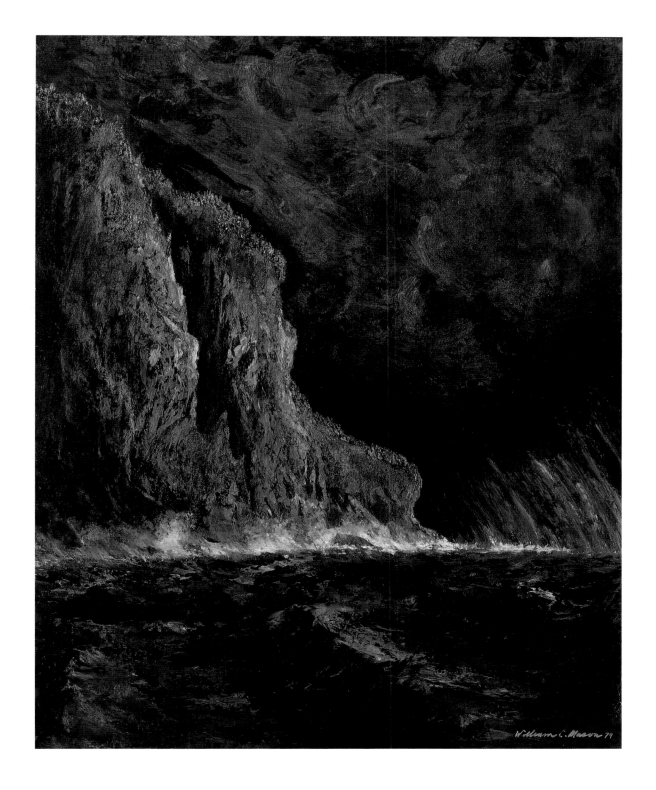

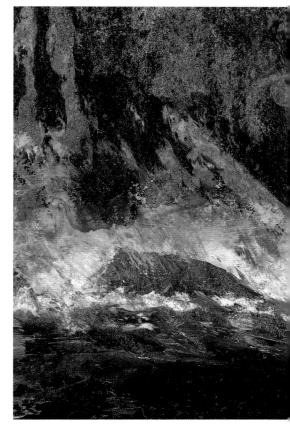

IN THE WAKE OF A SUPERIOR STORM 11 x 7⅞ inches

I HAVE MANY FOND memories of being windbound on Lake Superior and watching the storm clouds move out. The sun begins to break through, highlighting the distant headlands and the towering waves. After a big blow it can take one or two days for Superior to settle down. It's an exciting moment when the sun breaks through an opening in the clouds for the first time, illuminating the angry sea in warm light. I never tire of watching such a scene. I'm anxious to be off again, but I have never found being stormbound on Superior a hardship. The storm is over and gone all too soon.

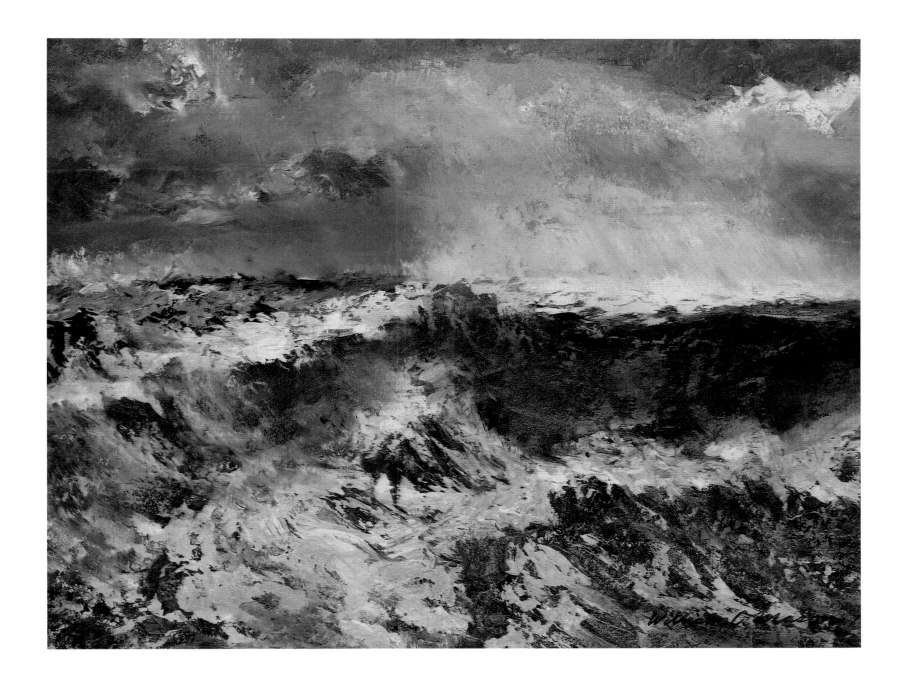

LAST LIGHT BEFORE THE STORM, SUPERIOR 8⅝ x 11⅜ inches

ONE OF THE MOST mesmerizing sights in all of nature is that of waves pounding on a rocky shore. Every so often a giant wave swells up in the distance. I wait in anticipation as it nears the shore. If the backwash from the previous wave is just right, the monster wave curls at the perfect moment and crashes against the rock, sending spray high into the air. Then I sit waiting with anticipation for an even bigger one. Occasionally my patience is rewarded by a freak giant. How do I capture such a sight in a still painting? If I freeze the action too sharply there is no sense of movement or power. It is always a challenge. If the rock face is sloping, the wave rolls up the incline, subsides, then flows back, only to be engulfed by the next wave. If the rock face is perpendicular, the wave smashes against the rock, sending spray high into the air. Then there's the imagination to deal with. I imagine being trapped out there in my canoe, nowhere to go, and I'm being driven towards the shore. There is no hope of landing. All I can hope for is to leave the swamped canoe, ride a wave onto the rocks, grab and hold on without being carried back into the maelstrom again and again. Viewing such a spectacle from shore is very different from being out there in it—as happened to me once. I was paddling solo in large waves, re-enacting one of my journeys along the Superior shore for a film. Suddenly a giant wave came out of nowhere and broke over the canoe, sending me swimming. Because of the threat of hypothermia from the cold water, I left the canoe and gear and headed for shore immediately. The undertow kept me from reaching the shore. I struggled for what seemed like an eternity. Finally a progression of smaller waves allowed me to break through the undertow into a cove. I will never forget the spectacle of the waves crashing into the vertical cliff face on my left and rolling up onto the jagged rocks on my right. I am sure my memory, or lack of it, has dramatized the event, but that's a liberty an artist can take.

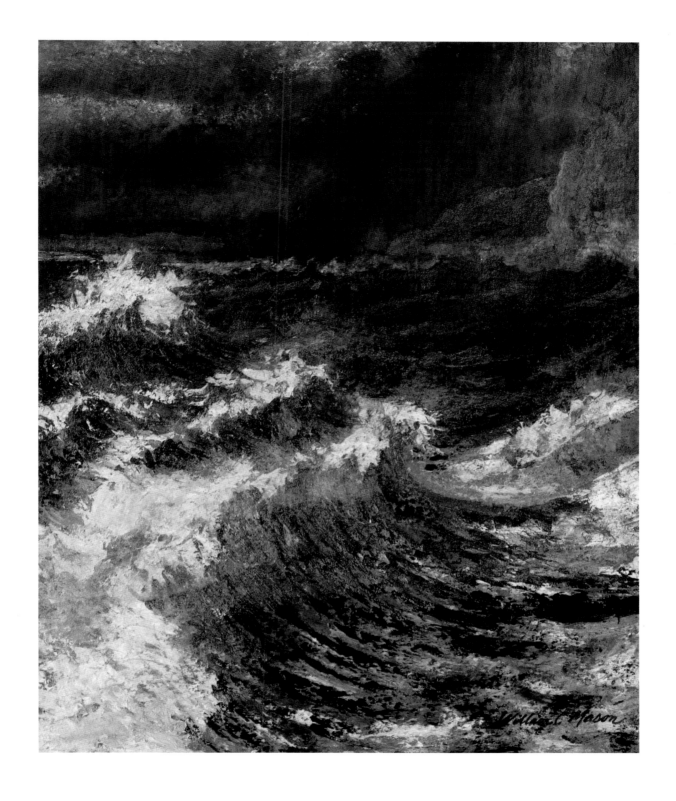

ROUNDING POINT CANADIAN IN A STORM, SUPERIOR 5 x 7$\frac{1}{4}$ inches

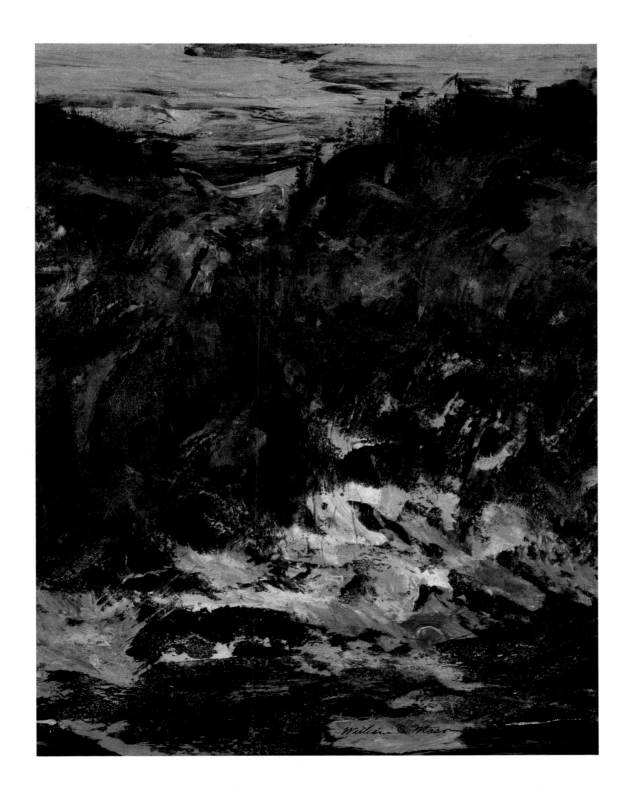

HEIGHT OF THE STORM, GEORGIAN BAY 7 x 5 inches

EVEN WHEN THE WIND isn't blowing in off Georgian Bay the trees on the outer islands seem to grow almost parallel to the ground. Paddling in the waves of Georgian Bay is far less intimidating than paddling in those of Superior because of the warmer water. And there always seems to be an island to nip behind for shelter. But a good blow on Georgian Bay is awesome to behold.

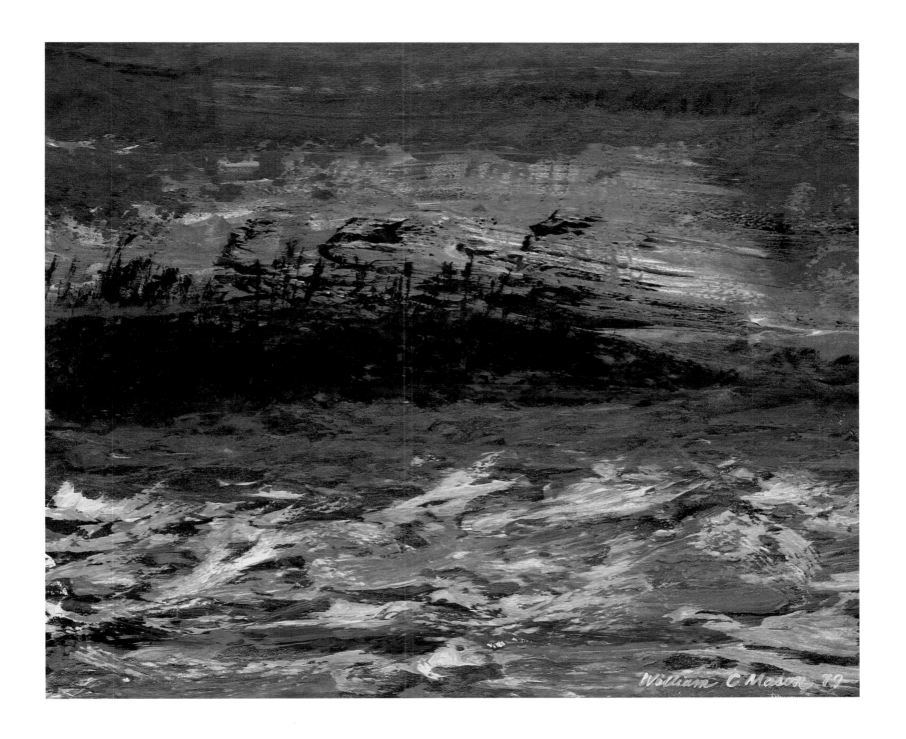

William C. Mason '79

HURRICANE ISLAND 8⅜ x 5 inches

THIS PAINTING LEAVES A lot to your imagination, possibly because it is a figment of my imagination. To some viewers it may seem chaotic. There are many individual experiences wrapped up in this painting, and I return to it again and again to rekindle my memories.

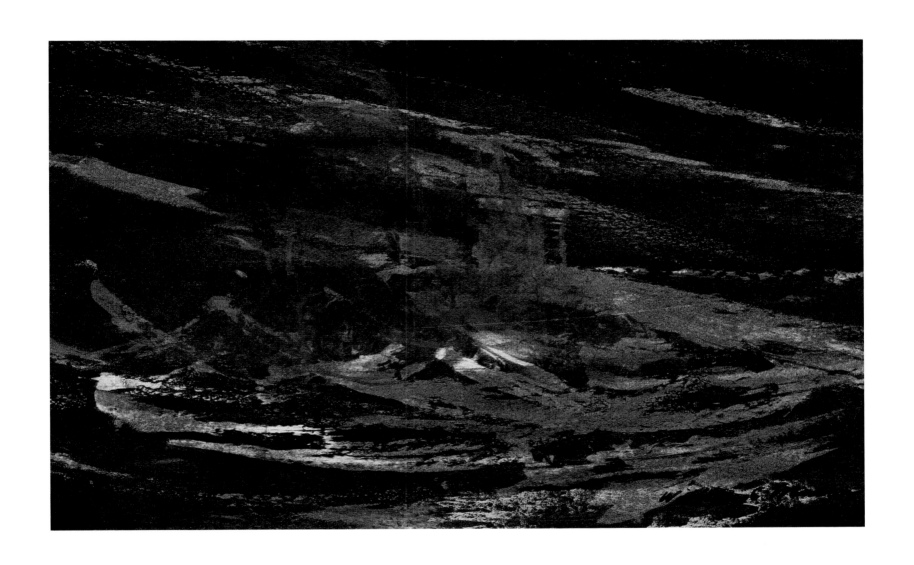

HOSTILE SHORE 7⅜ x 5⅞ inches

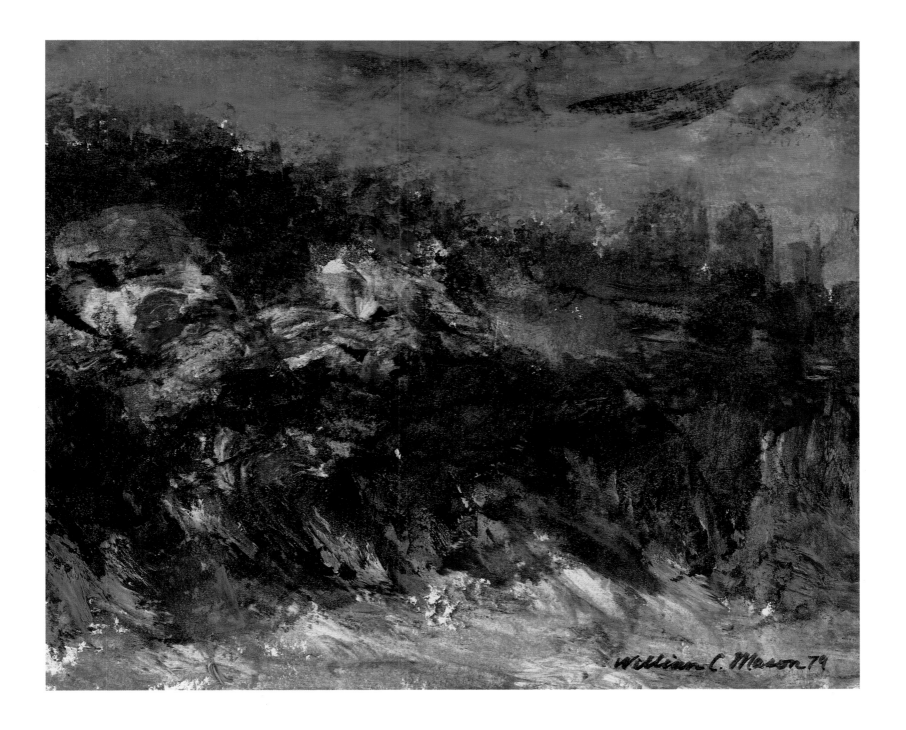

ROUNDING POINT CANADIAN IN APPROACHING STORM, SUPERIOR 5 x 7¼ inches

ONE OF THE MOST beautiful profiles that you'll see along the north shore of Superior is a place called Point Canadian. It intrigues me for several reasons. As I read more about the voyageurs I learned that this point of land was one of the first features they described. To the voyageurs this was a very intimidating, dangerous place. However, before reaching Point Canadian a canoeist passes a nice, big cove with a small island in the middle. The first time I saw it, it was just like I imagined it from the old black-and-white photographs of the logging days. I've paddled by this point several times, but only once, with a storm coming, did I have to turn back. Here, I've tried to capture the feeling that compelled me to make that decision. Should I keep going and try to make it to the next cove, or should I give up and turn back to the safety of the cove I've passed? This painting was done in the studio, and for a while I came very close to discarding it. I tried to salvage it, but it kept falling apart, until at last it just all came together, expressing the feeling that I was trying to portray.

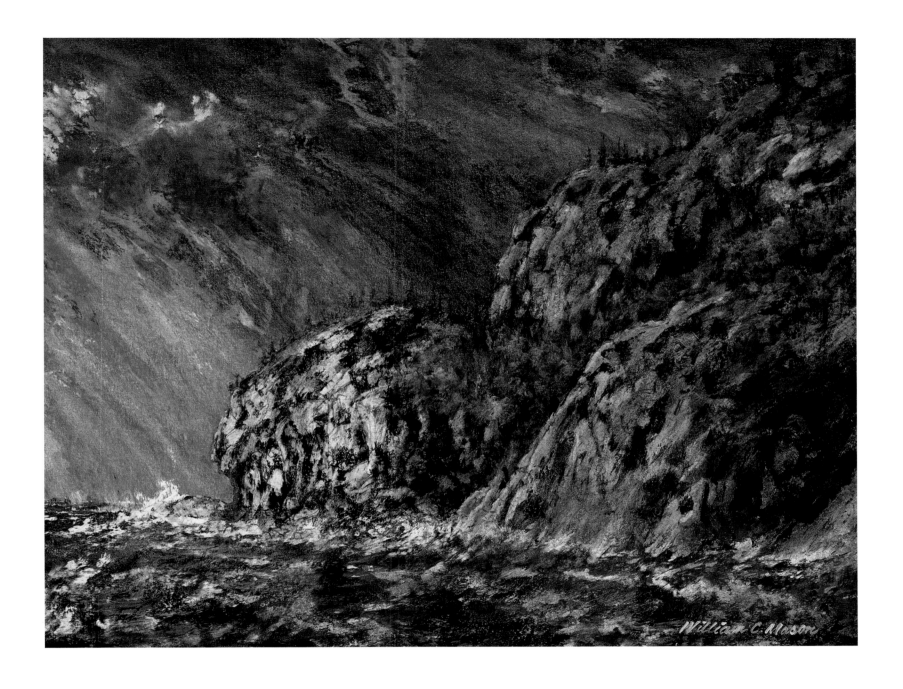

William C. Mason

PINE ISLAND STORM 19 x 7 inches

THIS IS ONE OF my last major efforts in watercolour before changing to oil-on-paper. To my consternation it is the most popular painting I've ever done. I've sold more reproductions of this painting than any other. I say consternation because, as much as I've enjoyed watercolour, I don't want to go back to it. I enjoy oil-on-paper too much. I would like to be able to say that it was done on-site in the rain, but actually it was rendered, partly in the shower, at home.

This island has a deep and special meaning to me. One of our favourite campsites when we ventured out from Pioneer Camp in the Lake of the Woods was situated near this island. In later years I guided numerous groups of children on canoe trips to this site. And we experienced many such wind and rain storms lashing this island as we peered out from the comfort of our tents.

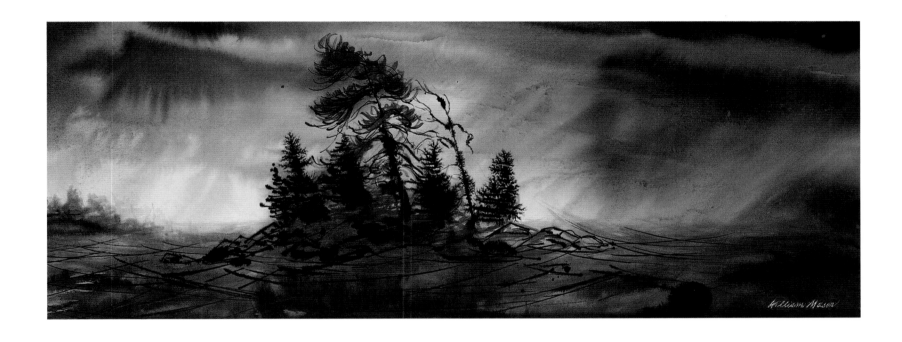

AFTERGLOW $8\frac{7}{8}$ x $6\frac{1}{2}$ inches

THE STORM HAS PASSED, the sun has set, but an eerie light lingers on the last of the storm clouds. The islands are barely discernible in the fading light. It's a scene I witnessed while making my first film, *Wilderness Treasure*, at Manitoba Pioneer Camp in Lake of the Woods. This film, about a boys' canoe trip, launched me on a twenty-year career in filmmaking.

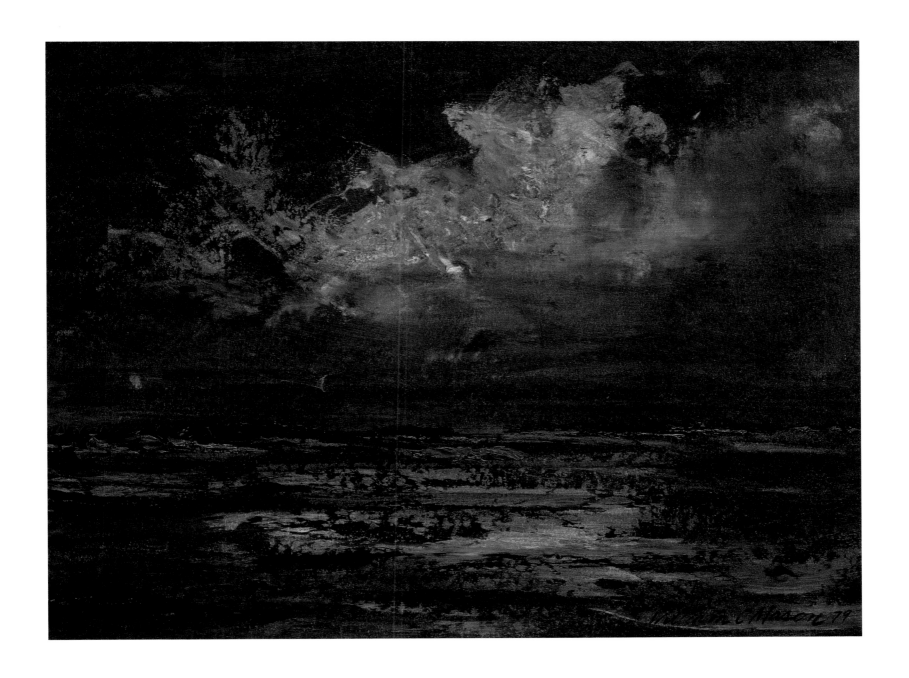

CRASHING SURF

A WAVE-WASHED VEIN OF ROCK $10\frac{3}{4}$ x $4\frac{1}{2}$ inches

IT'S FASCINATING TO WATCH the colours in a wave-washed rock. The colours glisten and dance in the surf. Here, I have attempted to capture the feel of the waves and texture of the rocks. I was striving for a translucent quality in the water to portray the sparkling clarity of Lake Superior.

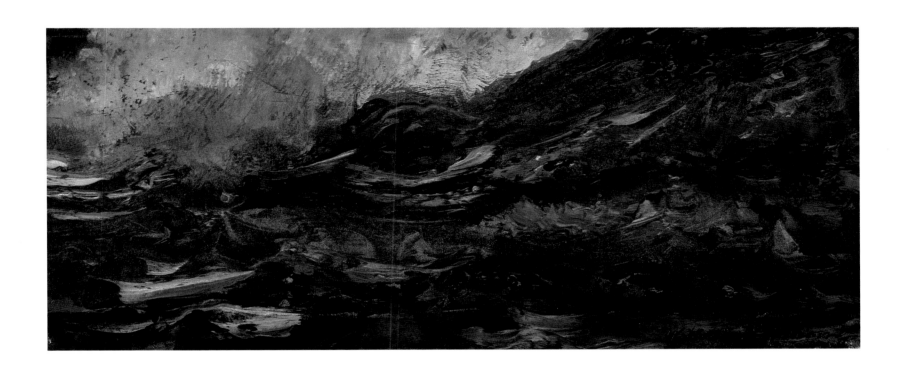

SURF ON ROCKY POINT, OLD WOMAN BAY, SUPERIOR $11\frac{1}{2}$ x $7\frac{1}{2}$ inches

THE DILEMMA IN PAINTING surf on a rocky shore is whether or not to freeze the action or to paint the wave in motion. In the background, huge rollers break on the offshore reefs. With three hundred miles of open water to the west, the waves resemble ocean swells.

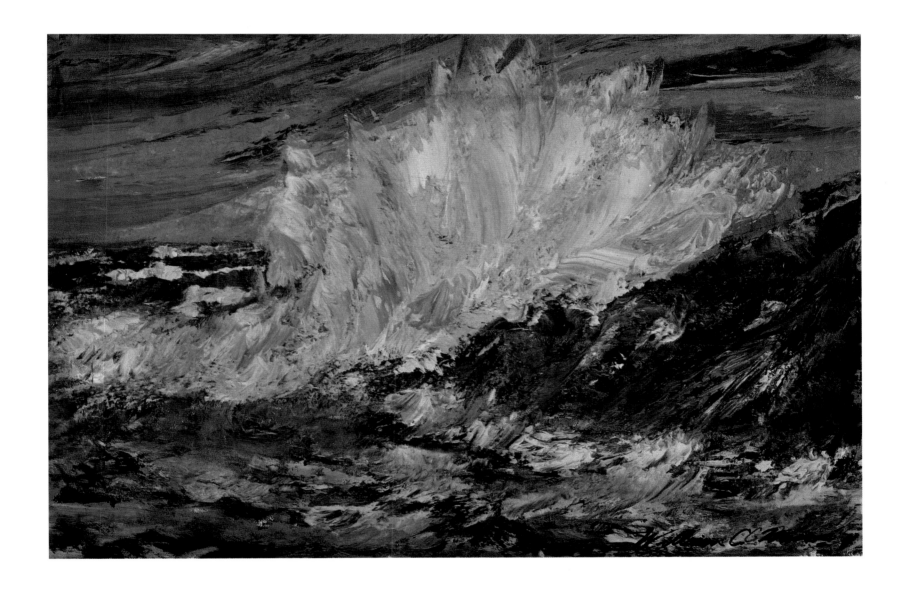

CRASHING SURF **109**

CRASHING SURF 8 x 8 inches

HERE, I TRIED TO capture just how it feels to be in a canoe and confronting heavy surf pounding a very rugged shore. It is both an awe-inspiring and fearful sight. I can't turn back but must keep going until I find a protective cove. To upset or swamp here is unthinkable.

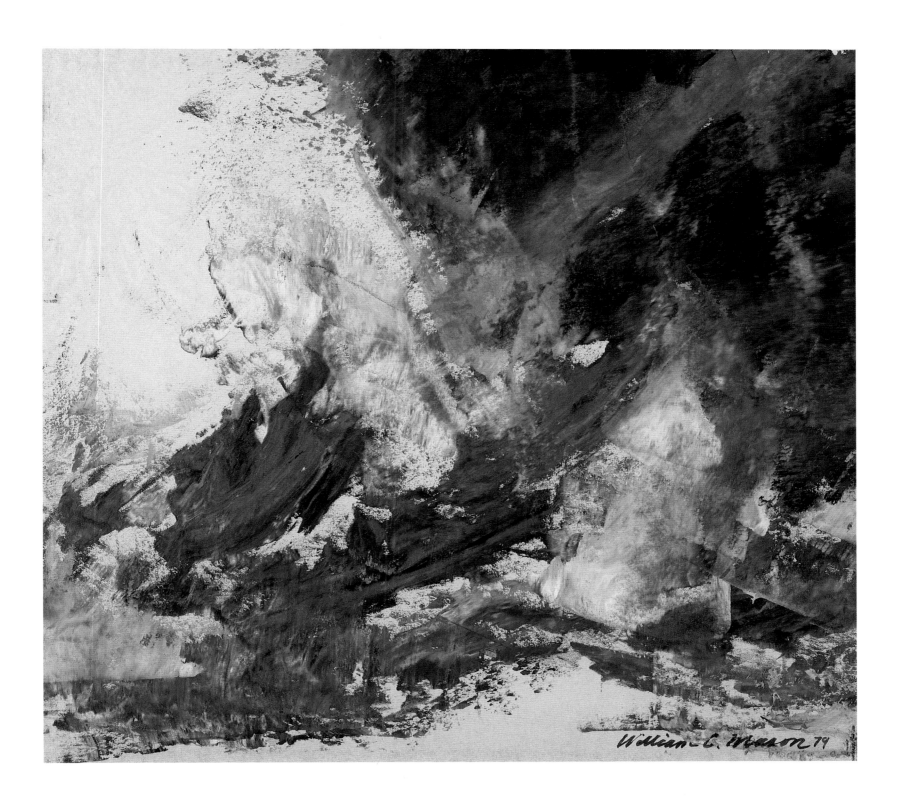

William C. Mason 79

LAKESHORE, FOG AND SURF 8 x 17 inches

WHEREVER THE SUPERIOR SHORE is protected from the full force of ocean-size rollers, the trees grow down to the boulder-strewn shoreline. The cold fog becomes trapped in the bays and coves and lifts very gradually. The waves are shorter and choppier. This painting only suggests things and leaves you to discover what you will.

LAKESHORE, FOG AND SURF detail

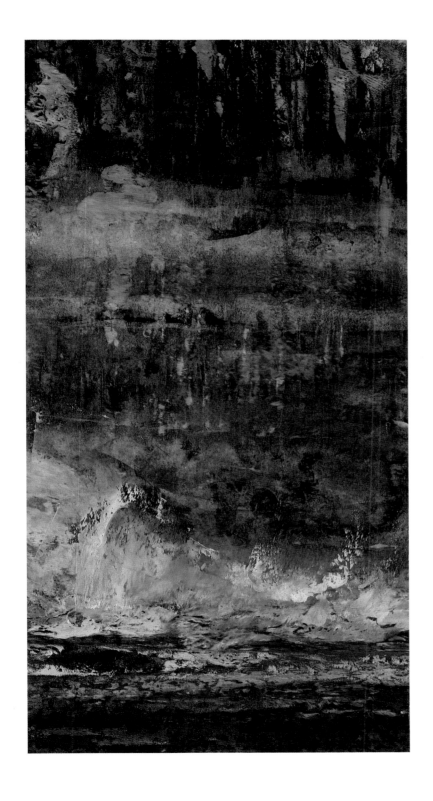

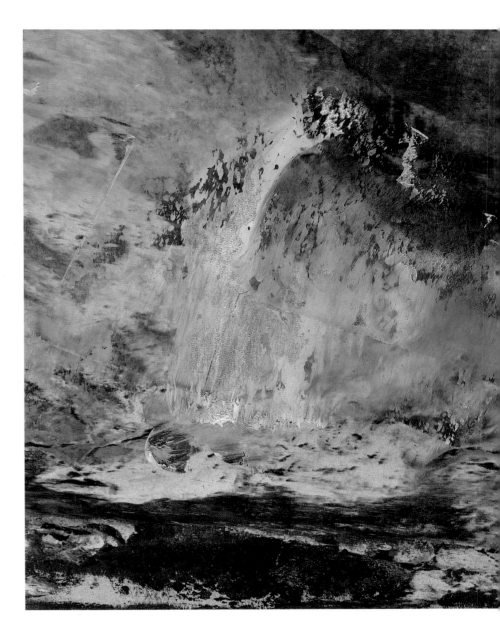

WATERFALLS

IMPRESSION OF WILBERFORCE 6½ x 5 inches

WATERFALLS ARE MY FAVOURITE subject. I would canoe for weeks to get to a waterfall. The more remote the better. There are many beautiful falls accessible by road, but the experience isn't the same. There's nothing like railings and trodden paths to kill the atmosphere of a beautiful falls. It's getting so one must go ever further afield to enjoy a falls in pristine beauty. But a few are still out there, flowing wild and free.

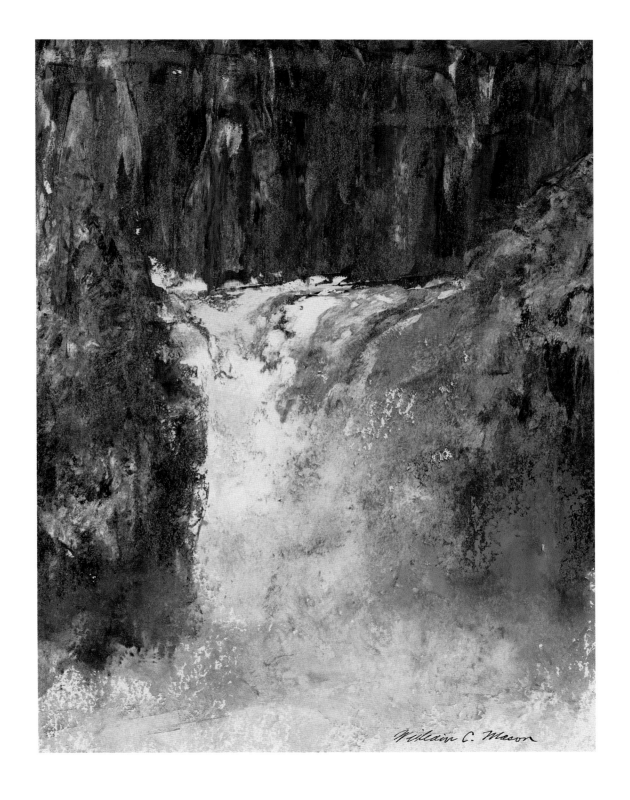

William C. Mason

IN THE DEPTHS OF WILBERFORCE CANYON I 3¼ x 6¼ inches

I GUESS I AM a bit of a romanticist. While I envy Turner and the age of sail in which he lived, it would make little sense for me to paint ships. The important thing for me is to paint what I know. I am a canoeist, and have been as far back as I can remember. To include a canoe, tent or campfire in a painting seems like a natural thing to do. But it is very difficult to do so without producing a schmaltzy painting. Unfortunately the reality of our waterways today includes pulp mills, logging, highways, motorboats, waterskiers, steel bridges and sewer outlets, all of which I photographed as a filmmaker and have no desire to paint. Unlike those in Turner's day most of today's disasters are no longer natural ones; they are created by us.

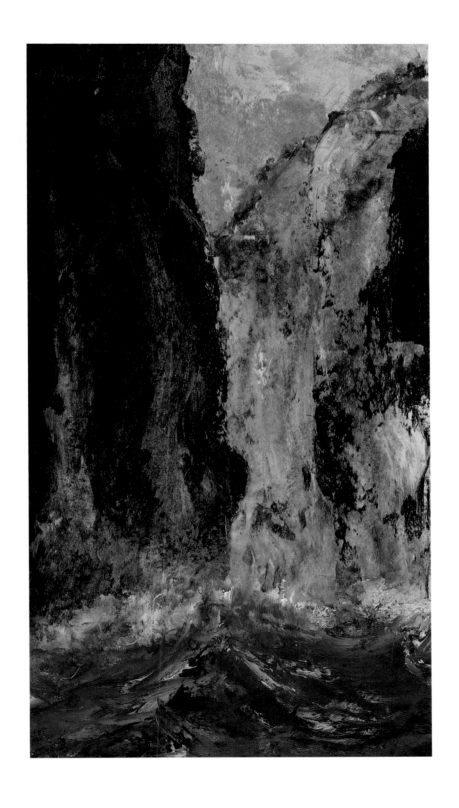

BRINK OF WILBERFORCE FALLS, HOOD RIVER $2\frac{1}{4}$ x $4\frac{3}{4}$ inches

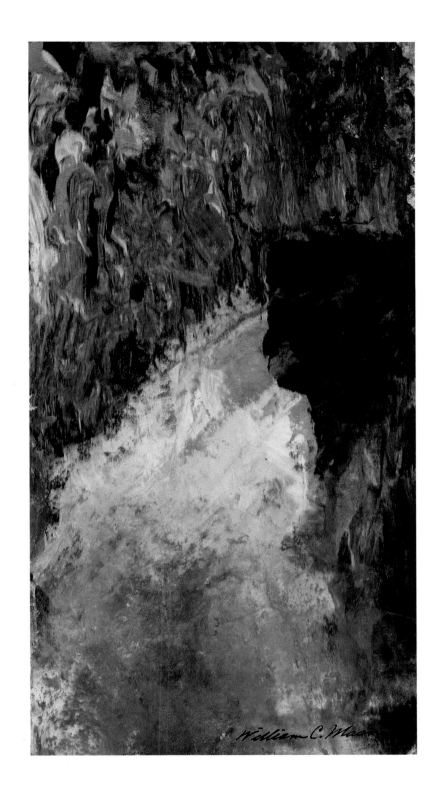

DENISON FALLS, DOG RIVER, NORTH OF SUPERIOR 12 x 10 inches

DENISON FALLS IS ON the Dog River, a river of many falls, with Denison as the grand finale. The approach above Denison is frightening. As you round a tight right-angle bend you are confronted with a gaping chasm leading to certain death. Just after the bend the river drops off into a narrow, straight canyon that plunges down towards the falls for several hundred yards. At the end of the canyon the river drops off a razor's-edge into a cauldron. The cauldron in turn empties over a cascade that is split by a great pyramid of rock. For the final drop, the plunging falls widen into a fan of foam. But it's not over yet. The seething water flows away to the right, into another canyon, before the final drop over a wide ledge. From there to the shore of Superior, the river is a canoeist's delight—a beautiful whitewater run all the way. Denison Falls was an intimidating subject to paint. To my surprise I captured what I was after in the first attempt.

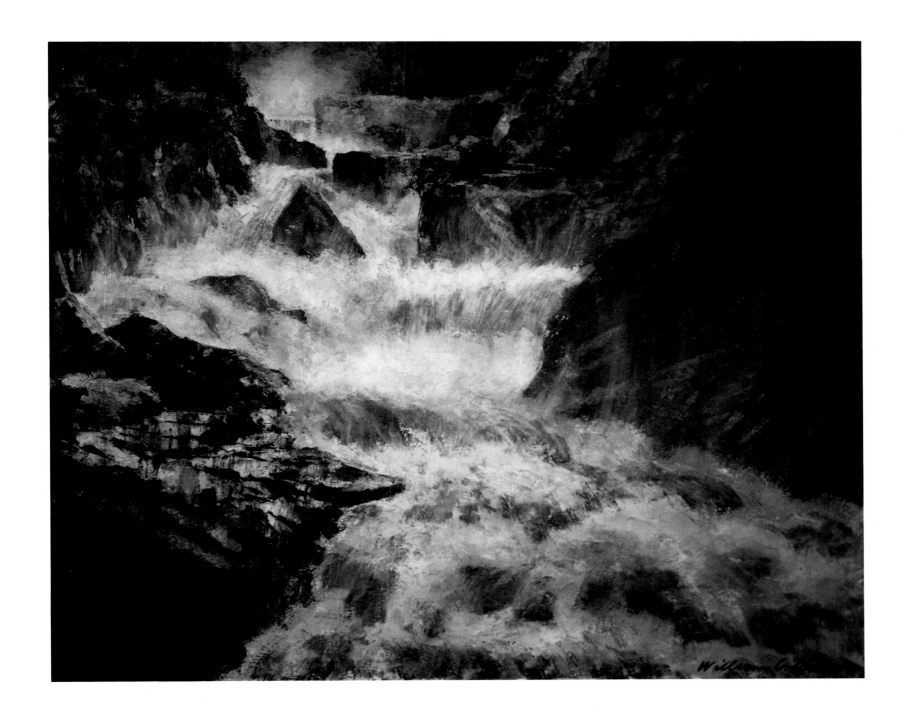

CASCADE FALLS, LAKE SUPERIOR 12 x 10 inches

AT ABOUT THE HALFWAY mark between Marathon and Wawa you round a point and are confronted with one of the most beautiful sights to be found along the rugged north shore of Superior. Here, Cascade Falls drops straight into Superior in twin plumes. I am fascinated by the wild, plunging falls and rapids of the rivers that flow into Lake Superior, but Cascade is the only falls that drops straight into the lake. All the others have cut their way upstream over thousands of years. I first saw Cascade in 1960 on a solo canoe trip from Wawa to Marathon. I had longed to do the trip for years, but everyone said it was suicidal. Then I heard that Pamela and Eric Morse had paddled it. So the following summer I set out to fulfil a long-time dream, and I've been paddling the shore almost every year since.

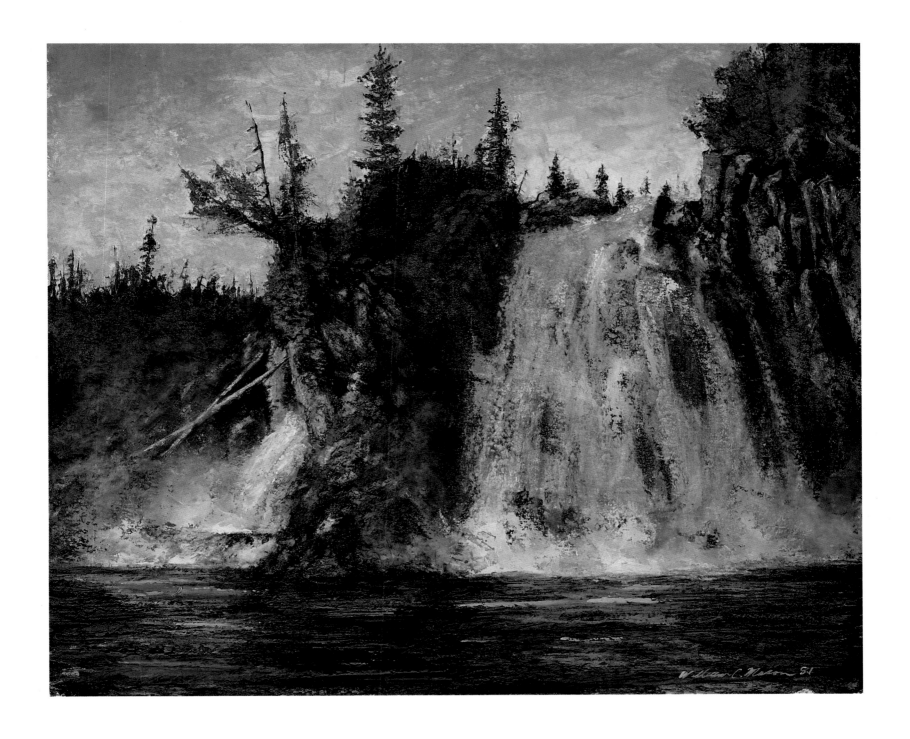

VIRGINIA FALLS, NAHANNI RIVER $16\frac{1}{4}$ x $20\frac{1}{2}$ inches

VIRGINIA FALLS IS QUITE possibly the most spectacular place in Canada. The best way to describe the falls is to compare it to a great symphony. The music begins gradually as the river meanders around gentle curves. The river is deceptively flat and tranquil, but when you watch the bank you realize that your canoe is moving swiftly. There is an ominous undercurrent to the music. As you round the last bend the river widens and slows. You look to the left and see an island of rock in the middle of the river. It looks inviting but to venture there would be to pass the point of no return. Just beside that rock the river drops into a long chute called The Sluicebox, well named because as the river races down toward the brink, it increases in ferocity, with waves exploding into the sky. The symphony builds as the whole river ploughs straight into a great pyramid of rock at the brink of the falls. The force of the water hitting the pyramid is almost incomprehensible, but it stands there defiantly, as it has for untold centuries. The symphony reaches its climax as two-thirds of the river is diverted to the right of the rock and drops off into space, plunging into a misty void of boiling spray. On the left, the rest of the river drops into a seething pool before cascading through a narrow gap and over the many ledges that form the canyon wall. The whole base of the falls is obscured in swirling mists from which the river emerges and races away into a thousand-foot canyon. The symphony ends as the river disappears from view. In my painting I have tried to capture the climax. Stand back and listen.

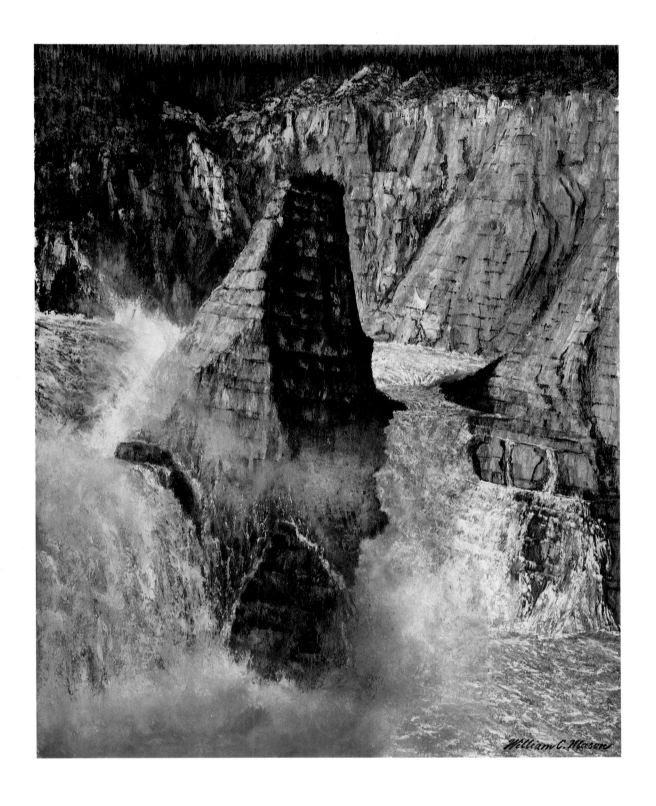

William C. Mason

VIRGINIA FALLS, NAHANNI RIVER detail

DEGAS SAID: "DRAW WHAT has stayed in your memory, then you'll only bring out what has really struck you, which is all that matters." He also said that he painted not what he saw but what he wanted others to see. Thus his work was not based on pure vision. Instead, he relied on what he remembered rather than on what he saw in a fleeting instant in nature. When I first read these words I was very excited because they accurately described what I had been attempting to do. However, I have done a number of more representational paintings because I also enjoy the challenge of capturing some of my favourite places in minute detail. For these, I employ the same loose and easy palette knife technique that I use in my impressionistic paintings. But it is a difficult technique to control or master, so my success ratio is very low.

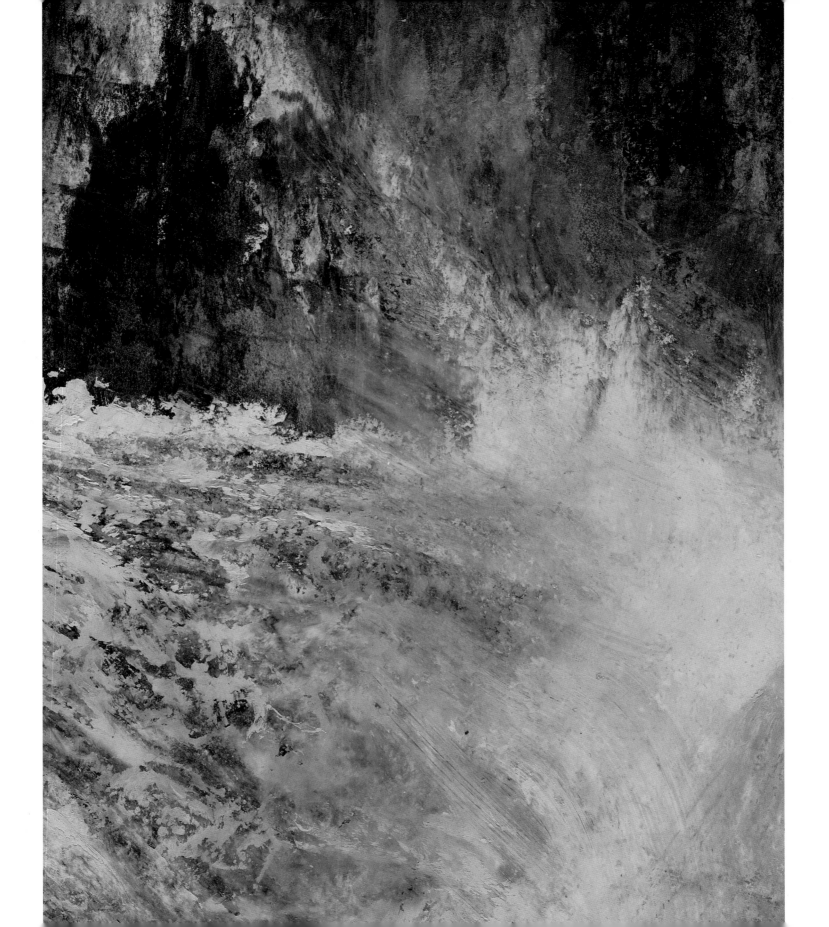

WILBERFORCE FALLS, DRY CHANNEL, HOOD RIVER $16\frac{1}{4}$ x $20\frac{1}{2}$ inches

WILBERFORCE FALLS IS ONE of the wildest and most remote areas in North America. Our view of the falls was the reward for a two-week canoe journey from the headwaters of the Hood River. Anticipation ran high as we followed our map. Suddenly the shores steepened and became cliffs. As we looked downstream the river seemed to disappear. We hastily eddied out to shore, pulled the canoes up and raced over the rocks for our first glimpse of the falls. Gingerly we picked our way along a narrow ridge out onto a pinnacle of rock. From here we could look straight into the face of the first drop. To our left, the cliff dropped away two hundred feet into the depths of the canyon. We were immersed in the roar of the falls. We wondered if Robert Hood had once stood peering into the canyon on the same spot. Hood was the artist on Franklin's ill-fated trip to the Arctic coast. Half of Franklin's men were lost due to exposure and starvation on their overland journey up the Hood River to reach Fort Providence before winter. During the agonizing trek, one of the guides murdered Hood and attempted to eat him. As I looked across the canyon I imagined I could see Hood standing on the other side sketching the falls. Remembering his sketch I could pinpoint the spot. It was possible to view the falls from an endless variety of angles due to the lack of trees and undergrowth. I spent many hours clambering over the rocks, trying to experience the falls from every conceivable viewpoint. I could have spent many weeks here. But as our party packed to leave on our third day, the hordes of mosquitoes that plagued us whenever the sun came out made our departure less reluctant. It's nice to know that Wilberforce Falls will never be crowded with tourists.

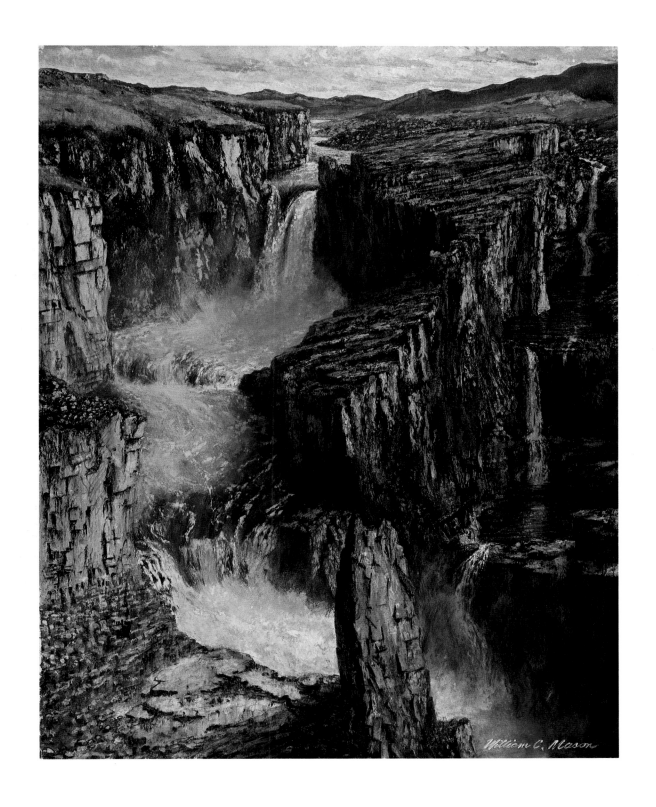

WILBERFORCE FALLS, DRY CHANNEL, HOOD RIVER details

WHEN VIEWING ONE OF my larger paintings, in this case *Wilberforce Falls*, which is 16 x 20 inches, I have a similar yet different problem from the miniatures. The rendition of Wilberforce Falls appears very realistic and meticulously painted, and yet it is not. The paint was applied with palette knives in a very loose, rugged and spontaneous manner. Here, each blow-up becomes a painting in itself and is perhaps more exciting than the painting as a whole because you can really get a feel for the paint. Isolating areas of a painting for closer study is a lot like viewing an entire scene then entering it for the purpose of discovering what's there. It can be a very creative process.

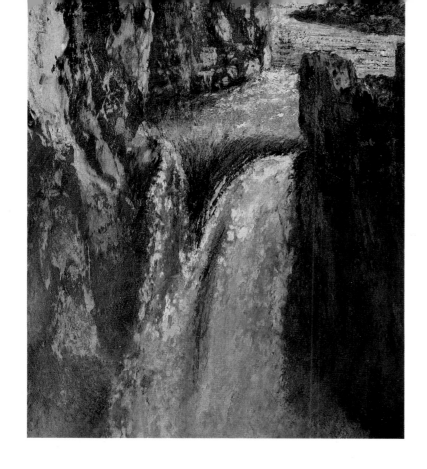

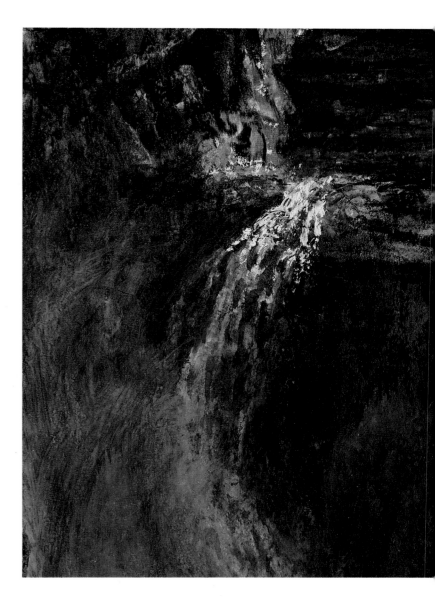

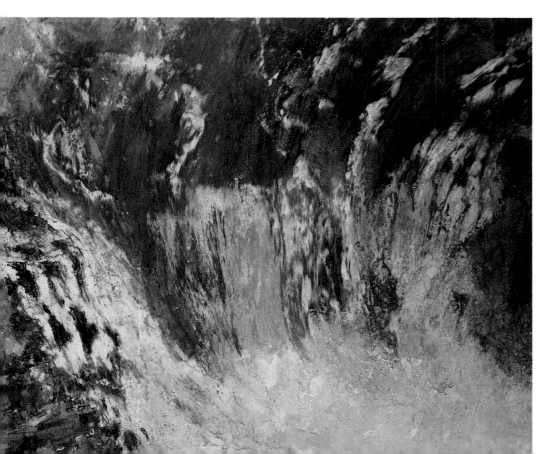

UPPER WILBERFORCE FALLS, HOOD RIVER, SKETCH 6 x 5 $\frac{1}{2}$ inches

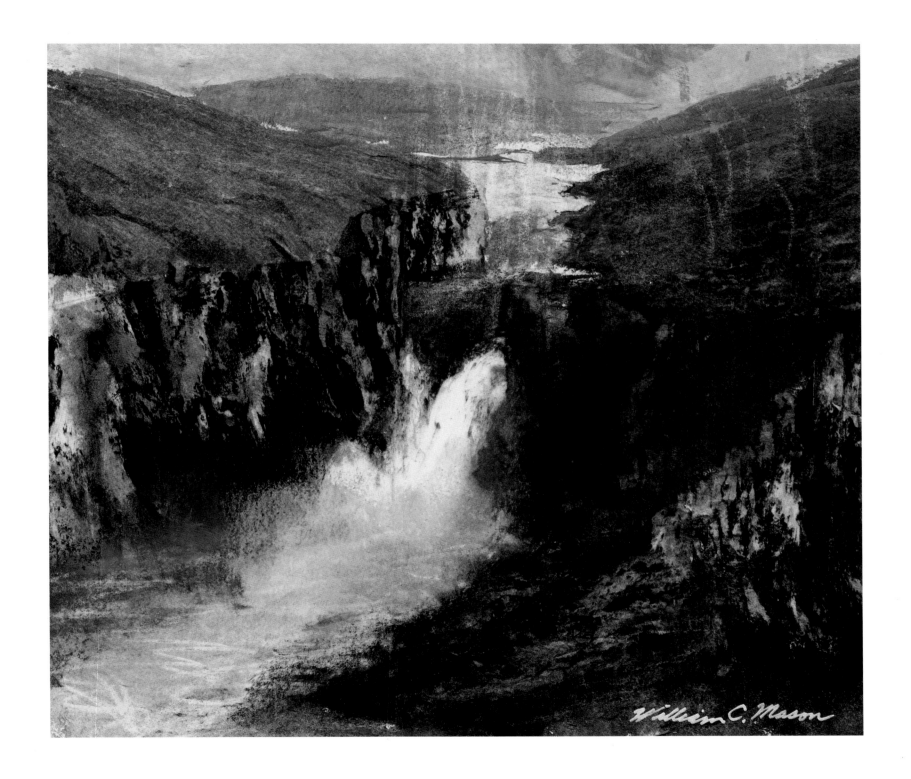

William C. Mason

RAPIDS

PETAWAWA HAYSTACKS $6\frac{1}{2}$ x $4\frac{1}{2}$ inches

RAPIDS CAN BE VERY deceiving. Often the biggest and wildest-looking rapids are not all that dangerous. If the water is deep and there are no keepers where the water is recycled back into a hole, a wipe-out is nothing more than an inconvenience. A turbulent, rock-studded rapid is more dangerous in a wipe-out, and it will destroy your canoe. Rollway Rapid, on the Petawawa River in Algonquin Park, is such a rapid. The high-volume rapids of the Ottawa River are huge but very forgiving. It's a great place to play and develop your skills. Swimming is all a part of the fun and the learning experience.

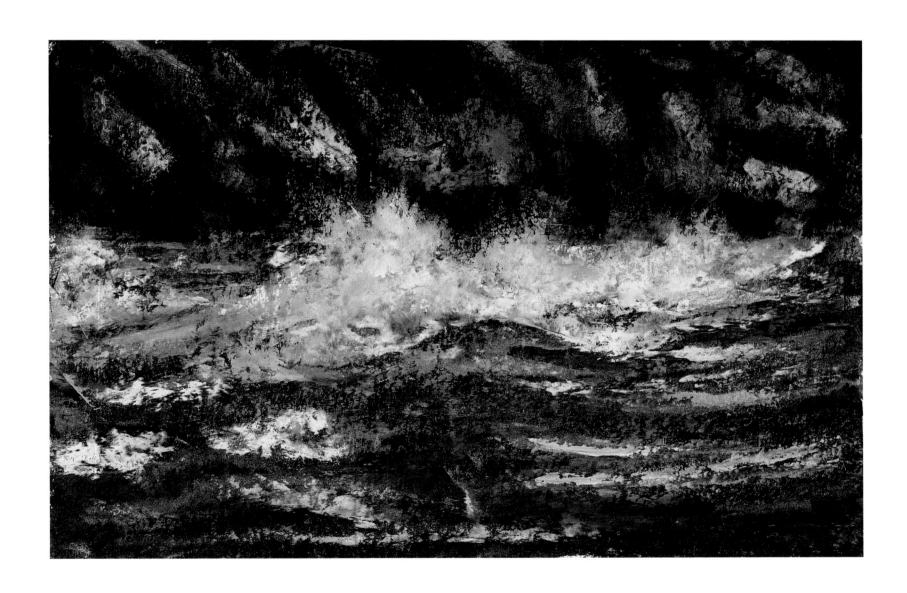

HIDDEN PATH BY FOLDED ROCK 8 ½ x 6 inches

THE PRICE YOU MUST sometimes pay for a spectacular waterfall is a long and arduous portage, but I wouldn't have it any other way. It's the portage that separates the canoeist from the noise and the litter. If you can reach a beautiful spot by road or powered vehicle, the chances are you will be knee-deep in litter. The deeper you go into the wilderness, the less litter you will see, even though it must be carried out over the portages. The part I like best about portaging is the walk back for the second load. You see things you would never see while staggering under a ninety-pound pack or an eighty-pound canoe. I've seen portages in parks that have been widened and improved, but I would prefer that they be left alone. We always have to improve everything. Our culture is not very good at doing nothing. Sometimes when I'm resting I think back to some of the portages I've made. I can remember portages that could best be described as a death march. There was one on the Petawawa that began by heading straight up. It twisted and turned in a series of switchbacks that were barely wide enough to pivot a sixteen-foot canoe through. When it rained it was like trying to climb a toboggan slide. It was a real killer, but it sure felt good when it was finished. And the scenery was great when you finally got to the top. Sadly, anyone canoeing the Petawawa River now won't know what I'm talking about because the park crews cut a new trail through the rock face beside the river. On a river journey by canoe, doing a portage properly and enjoying the scenery along the way is just as important as paddling the canoe. Not that you would catch me portaging a rapid that was runnable, unless it was to carry the canoe back up to run it again. If it weren't for rapids, falls and their accompanying portages, there would be no wilderness, no place to hear the cry of the loon. Let's keep our portages wild, the wilder the better.

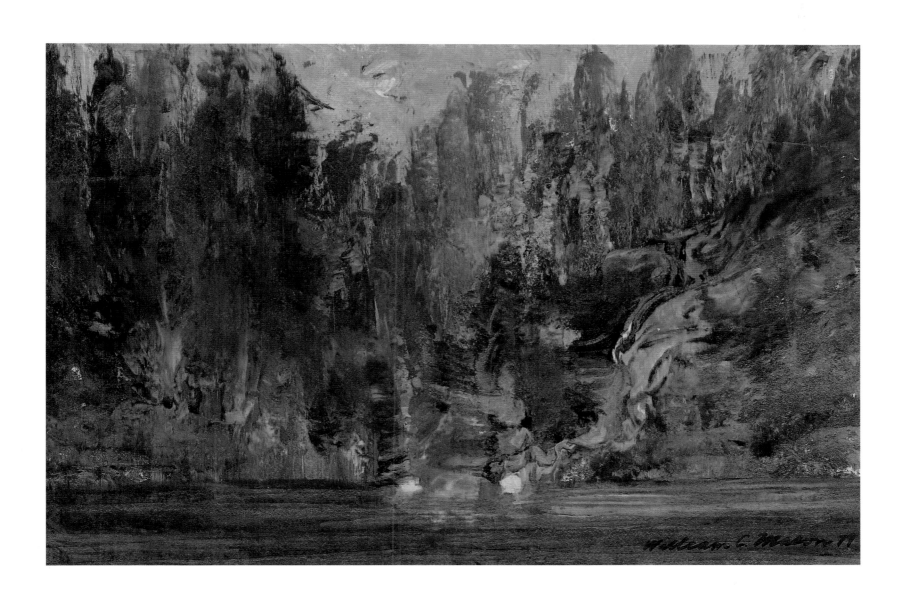

PYRAMID ROCK RAPIDS, PETAWAWA RIVER 12 x 10 inches

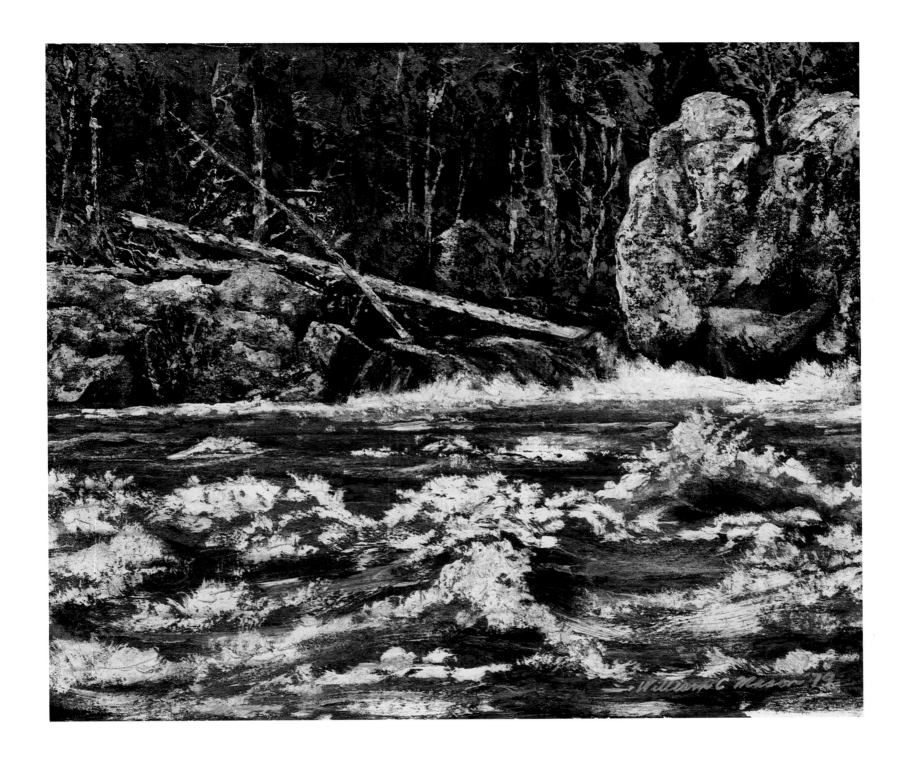

RED CANOE IN RAPIDS, FALL COLOURS, PETAWAWA RIVER 5 x 3¼ inches

MY FIRST SWIM THROUGH a rapids happened a long time ago, in 1952 to be exact. I had learned to run rapids on my own, as there were no canoe courses on whitewater back then. In fact the word was "only fools run rapids." At that time I was two years into my whitewater career. I guess I was one of the originals and had worked my way up to some pretty interesting stuff on the Whiteshell River in Manitoba. And then it happened. I couldn't negotiate a quick turn and broadsided onto a rock. I hit the water trying to get clear of the canoe. It rolled down the rapids broadside, looking very much as though it was out for revenge for all the abuse I had subjected it to over the years. Each time it rolled over, another piece was missing. It never quite caught up to me. I gave it a decent burial and walked out. My recollection of the event is as vivid as ever, and I was reminded of it when doing this painting thirty-seven years later.

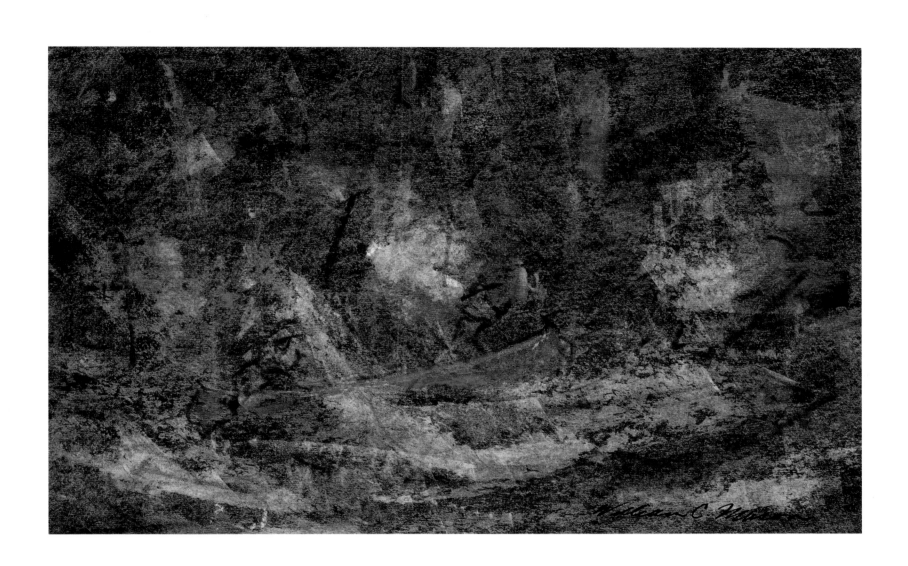

IN THE DEPTHS OF WILBERFORCE CANYON II 3 ¼ x 5 ½ inches

WHEN IT COMES TO swimming rapids, I doubt that many people know how it feels better than I do. I have had more than my share of swamps and dumps. I'm pretty sure it's because of my canoeing partners! In any case, the view from within the rapids is very different than the view from shore. Most dumps are no big deal, but there are a few that stand out in my memory, and one that I'll never forget. It was the closest I ever came to leaving this life and moving on to the next one. We were attempting a run of Wilberforce Canyon on the Hood River. The river plunges over Wilberforce Falls into the canyon and twists its way between two-hundred-foot cliffs for about two miles before exiting the canyon. There are five rapids in the canyon, and we had made it through the first and second rapids with some difficulty. The third one didn't look all that difficult from up on the canyon rim, but once we began the run we realized we had bitten off more than we could handle. It was a swim I won't forget and don't care to repeat. I spent a lot of time underwater and remember well the rare glimpses I was able to catch of the towering cliffs racing by. The view I remember most vividly though was the one I got moments before we were swallowed up in the waves. It looked like a wall of seething foam smashing into the cliff face. My partner, Wally Schaber, and I knew we were about to spend a lot of time underwater. We attempted to back ferry away from the worst of it, but the diagonal curling wave on the edge of the V flipped and buried us. It is probably quite true that the story gets better with the telling, but this painting gives a pretty good idea of how it felt.

IN THE DEPTHS OF WILBERFORCE CANYON II detail

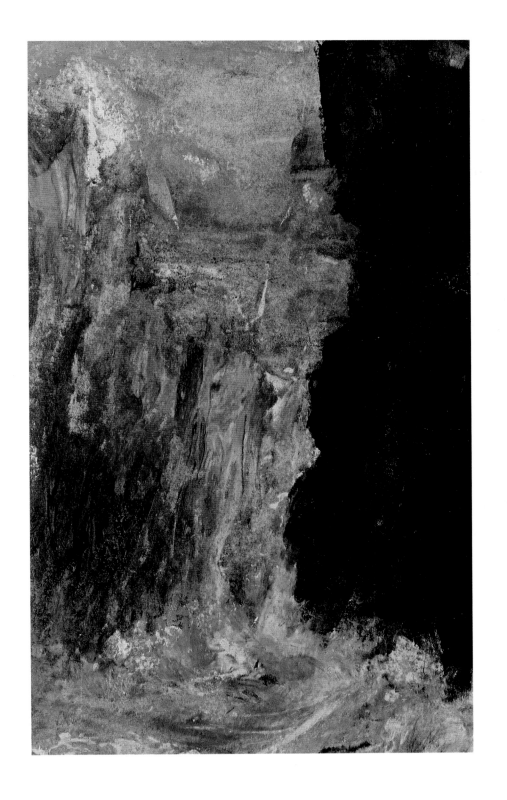

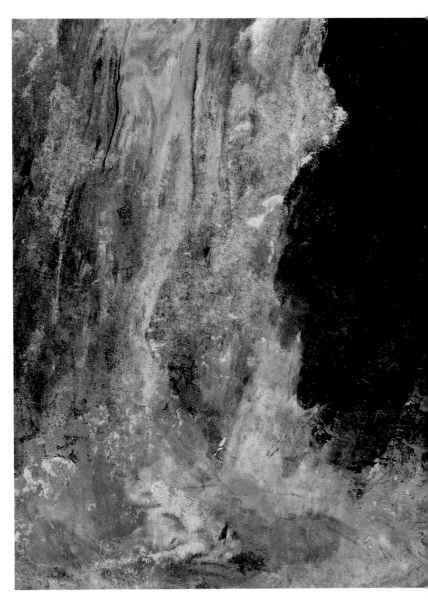

CACHE RAPIDS, NAHANNI RIVER 9½ x 11¾ inches

CACHE RAPIDS ON THE South Nahanni River is a rapids that whitewater canoeists look forward to in one of two ways—either with trepidation or with anticipation. The centre of the rapids is a wild maelstrom of plunging water that very few people have attempted to run. To my knowledge, everyone who has tried it has gone swimming but managed to wash out at the bottom. The left side is the easier route, but it is filled with swirling currents that really throw the canoe around. So any way you look at it, it's an interesting stretch of water. I love the place because of the composition. Across the river and beyond the sheer cliff face, the mountains in the distance rise almost to the sky. I love the soft feeling that the atmosphere gives the distant mountains. I painted a canoe into this scene to give a sense of scale and to help the viewer feel as though he or she were there, experiencing the run through this spectacular place. My companions are just skirting the edge of the big water so they can have a little bit of a thrill but not be taken into the big canoe-eaters out in the centre. The paint was applied with palette knives, except for the exploding waves in the centre of the rapids. Using a palette knife gives me a feel for the great slabs of rock plunging hundreds of feet in sheer cliff faces and also seems to lend itself to capturing the feel of the straight spruces. When the paint has dried I enjoy using glazes, an art that seems to be losing favour. I find that they provide atmospheric effects that make the painting come alive. A cool glaze is best for the shadows and a warm one for sunlit areas. I can push the mountains back and forth in the distance with these glazes.

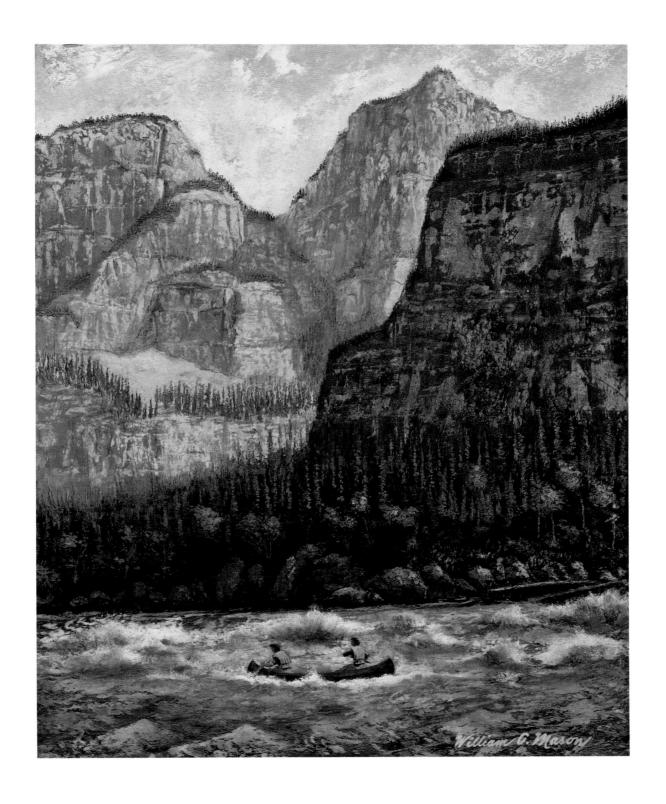

CAMPSITES

PULPIT ROCK, NAHANNI RIVER $9\frac{1}{4}$ x $11\frac{3}{8}$ inches

ABOUT A DAY'S JOURNEY below Virginia Falls you come drifting down upon what appears to be an absolute dead-end to the river. The rock faces ahead and on the right soar eight hundred feet above the water, and it isn't until you get very close that the river suddenly opens up to the right and there you see what is known as The Gate. This is the gateway to the Third Canyon. It is also known as Pulpit Rock, because coming out from the left there is a great, soaring pinnacle of rock. Although it appears to be a fearsome-looking place as you enter, The Gate offers a beautiful drift around the corner as you look up to the towering cliffs above. Before we enter The Gate we usually camp at a picturesque spot that looks right down through it. There is no sense of the immensity of this place until you've climbed the cliff on the left; from there, the huge pulpit looks quite small and our canoes on the beach mere specks. Even then, you still don't have much of an idea of how high these cliffs are and how narrow The Gate is until you push off the next morning and the canoe ahead of you becomes almost a dot as it passes Pulpit Rock. We are always amazed at how calm the water is, despite its swiftness as it surges through this narrow gap. The reason for this calm surface must be the tremendous depth of the river as it is confined between the rocky walls. I've sketched here four times and it never seems the same. Depending on the time of day and the cloud conditions, the light ricochets from cliff to cliff, creating the most amazing colours.

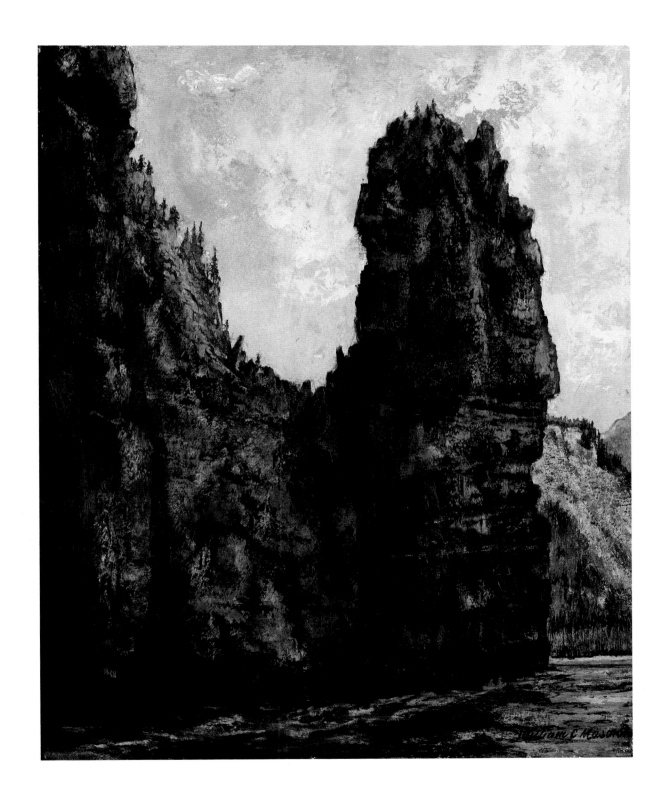

FIRE AT THE CONFLUENCE OF LITTLE NAHANNI AND SOUTH NAHANNI RIVERS 12 x 10 inches

THE LITTLE NAHANNI FLOWS from the south and joins the South Nahanni far above Virginia Falls. The rapids of the narrow, fast-flowing Little Nahanni are huge and are quite unlike the rock-studded rapids of the upper South Nahanni. It's getting late and we've been canoeing all day in air thick with smoke. Finally we see the flames as fire licks the trees on both sides of the river. The river ahead is swallowed up in the smoke. I want to camp but it's decided we should run through the smoke and camp on the gravel bar where the Little Nahanni joins the South Nahanni. Before pushing on, we soak our clothes, hats and neckerchiefs to protect us from the smoke and heat. It's an exciting run. We can see just enough to pick our way down the rapids. Occasionally a tree bursts into flames. At last we emerge from the smoke and continue down the river until we reach the gravel bar. We pitch camp and roll the canoes over for the night. I look back up the river as the smoke clears for a moment, revealing a blood-red sun. The reflection is like molten gold. I am glad that we didn't camp above the fire. The wind is blowing away from us and up the river. Fire is a common occurrence in this vast wilderness. There is no attempt to fight it because fire is accepted as a natural element in the ever-changing forest. In the Nahanni Park, forest fires are allowed to burn unless they are endangering lives or a park warden's cabin—an indication that we really are in a true wilderness.

Four years after our run through the fire on the Little Nahanni, I returned and was amazed to find that renewal was well under way. Beautiful lime-green regrowth was springing forth among the blackened remains of trees.

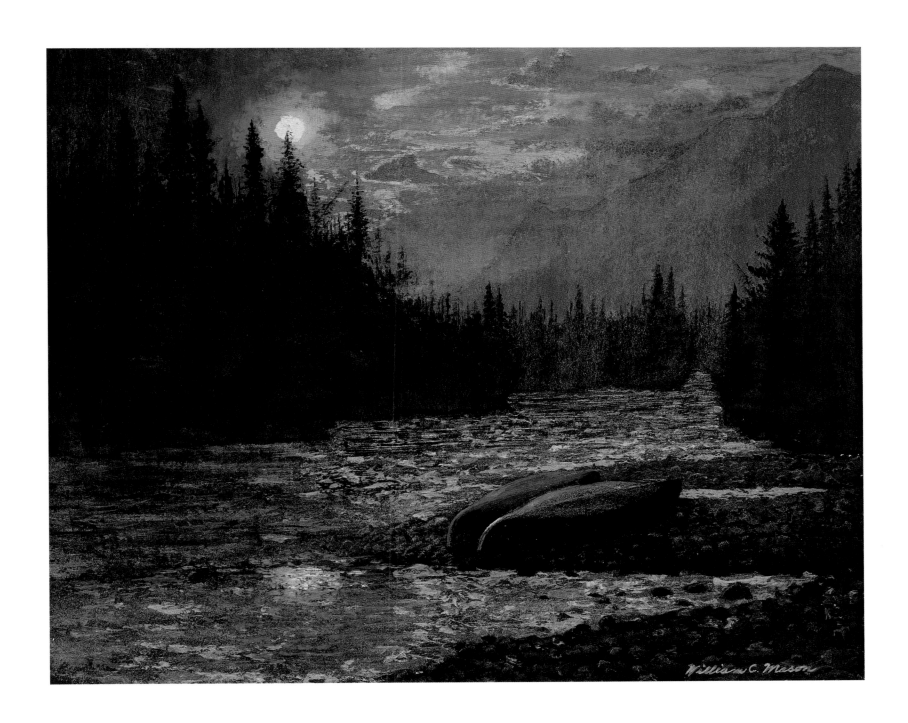

William C. Mason

ALPENGLOW ON THE MOUNTAIN RIVER 20 x 16 inches

ONE OF THE GREAT pleasures of Arctic canoeing is the all-night sunsets. In summer the sun barely dips behind the mountains, so the warm, beautiful evening light lasts for many hours. We have set up our camp at the mouth of the second canyon on the Mountain River, supper is finished and the dishes have been put away. Each of us is lost in his own thoughts as we wander off to enjoy the alpenglow in the mountains. We never tire of watching the light as it plays across the peaks and silhouettes the spruces in the foreground. Other than our party of six, there is probably not another human being within three hundred miles. When I look at my world map, which I like to carry on wilderness trips, I am struck by the fact that if we travelled east we would not cross a road until we reached Norway. I cannot believe that God ever intended us to overrun the earth at the expense of all other living creatures. Somewhere on earth one species of life becomes extinct every day. I look over at my companions, who have gone their separate ways, and wonder what each of them is thinking.

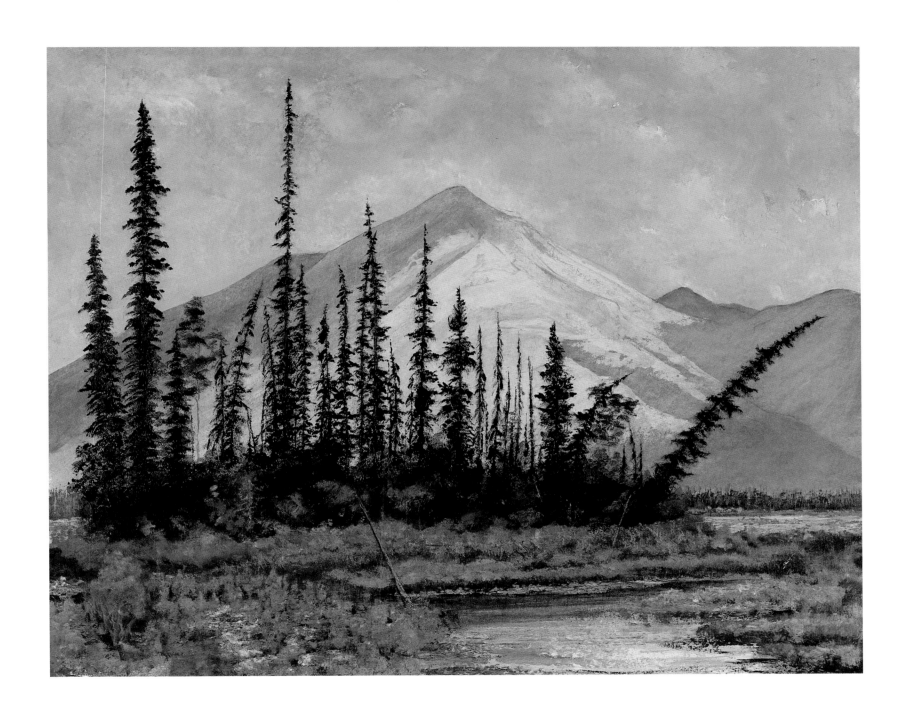

CAMPFIRE, PUKASKWA RIVER 12 x 10 inches

IF I HAD TO choose one single aspect of wilderness canoeing that I love most, it would be the campfire. The more remote the location and the greater the number of portages between me and civilization, the greater my sense of pleasure. When I stare into those red-hot burning embers my imagination can soar to anyplace I have ever been. Given time, I can remember almost every campfire I have sat before, and I long to return there. This painting is of one of my favourite campsites on the Pukaskwa River. I am camped on the inside of a sharp bend. As the sun sets, the camp is bathed in blue shadows, but just overhead the smoke from the fire climbs into the sunlight. Across the river is a cliff that rises straight up for eight hundred feet. The climb to the top follows a cascading stream bed to the back of the mountains. It's a tough climb, but the view looking straight down on the camp is worth the effort. The scene is so spectacular that I have used it in several films, including *Waterwalker*.

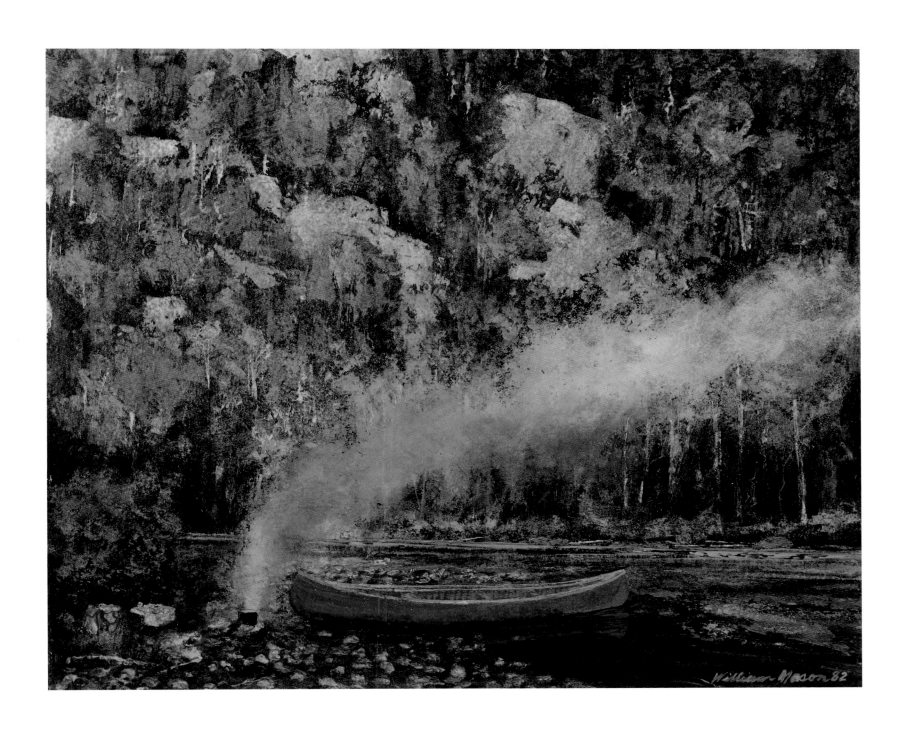

CAMPFIRE GHOSTS $3\frac{7}{8}$ x $7\frac{7}{8}$ inches

I KNOW OF NOTHING more mystical than the campfire. Your enjoyment of this painting of the campfire is determined by your imagination. It could be any campfire, anywhere. It could be when you are sitting alone or with many people around the fire. The reflections of firelight could be from tanned faces or from lichen-covered rocks. And what of the apparitions looming in the background? Each time I look at this painting they change, and I hope they continue to do so.

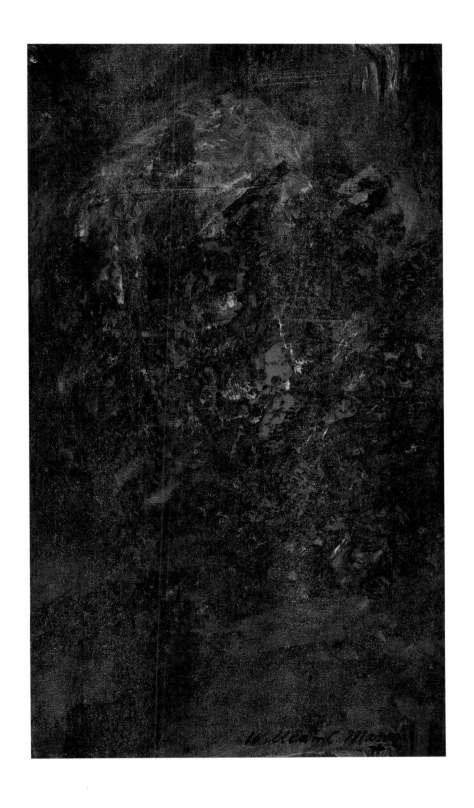

AFTERWORD

The ability to create is one of God's greatest gifts to mankind. It's one of the things that separates us so dramatically from the rest of the animal kingdom. But it's also at the root of our destruction of the natural world. In so many of our activities we have to destroy something in order to create something else. This is particularly true of forests. We get rid of the forests in order to build something in their place, or we destroy the trees in order to make them into something else, such as the paper I am writing on or the roof over my head. We assume that in time the forests will grow back so we can harvest them again, but sadly, statistics reveal that in much of our forested lands this isn't happening. Volumes have been written on the subject, but it all boils down to stupidity and greed. It is this reality that takes some of the joy out of painting. As I paint, my mind is free to wander, and too often it bogs down in the grinding war that all of us are waging against wild things. I guess a great part of the driving force behind my art has been the need to share my concern for wild places and their inhabitants. Most environmental campaigns have as their premise the conservation of wilderness for the benefit of our children and their children, but that's a lost cause. We are far too greedy as individuals and as nations for that approach to work. The only approach that has any hope of success must be based on compassion for our fellow humans and for all other living things. They all were created as a part of the whole and have a right to exist.

As I paint I love to think of the people who once lived here and how they saw themselves in relation to the land. It's as if they are talking to me, and out here I have time to listen. Consider the words of Tatanga Mani, or Walking Buffalo, a Stoney Indian: "Did you know that trees talk? Well, they do. They talk to each other and they'll talk to you if you listen. Trouble is, white people don't listen. They never learned to listen to the Indians, so I don't suppose they'll listen to other voices in nature. But I have learned a lot from trees: sometimes about the weather, sometimes about animals, sometimes about the Great Spirit." The words of the native people reflect a relationship with the land that does not come easily or naturally to our culture. Almost all of the recorded speeches of the native people reveal a profound belief in a Creator, while our culture, so far removed from the natural world, continues the debate over whether or not the Creator even exists. The depth of our relationship with nature depends to a great extent on how we travel. We can enjoy the view from a car, train, aircraft, motorboat, or snowmobile, but to achieve a relationship with the land one must travel on foot or by canoe. Even those of us who do are often in such a hurry that we see, hear and feel very little. Too often it is the destination that is important, not the journey itself. One of the wonderful aspects of painting is that it takes time. A lot of time. It forces me to look long and hard at my subject, to study and assimilate every detail and then to make choices as to what interests me. It is pointless to attempt to record every detail. I could never do justice to what I see. The forest that God created inspires me to create a painting that I hope reveals how I feel about it. That's what creativity is to me.

LIST OF THE WORKS

11 Chestnut Prospector Canoe
 Private Collection

17 Precambrian Reflections
 Edwin Martin

19 Precambrian Reflections detail

21 Windless Day
 Mason collection

23 Swamp Stump Reflection
 Dan McKenzie

25 Beaver Lodge Swamp, Pukaskwa
 Headwaters
 Dan McKenzie

27 Lily Pad Swamp in Mist, Pukaskwa
 Headwaters
 Bob Williams

29 Edge of a Grassy Swamp, Pukaskwa
 Headwaters
 Mason collection

31 Morning on Lake of the Woods
 Elizabeth McKenzie

33 Georgian Bay Shoreline, Byng Inlet
 Mr. and Mrs. R. W. McLachlan

35 Old Woman Bay, Morning Mist
 John and Sheryl Selwyn

37 Algonquin Mist
 Owner unknown

39 Pinnacle Rock in Mist, Devil's
 Warehouse Island, Lake Superior
 Mason collection

41 Offshore Sunrise, Superior
 Private collection

43 Northern Lights and Spruces
 Mason collection

45 Sundogs and Spruces
 K. R. Thomson

47 Spruce Forest Reflections
 Wilber Sutherland

49 Georgian Bay Evening
 K. R. Thomson

51 Mountain Near Roger's Pass
 Gary Watts and Fay Hjartarson

 The Sleeping Giant, Lake Superior
 Mason collection

 Falls on the Sand River,
 Lake Superior
 Mason collection

 A White Pine Study
 Mason collection

53 Mountain Near Roger's Pass detail

55 The Sleeping Giant, Lake Superior
 detail

57 Falls on the Sand River,
 Lake Superior detail

59 A White Pine Study detail

61 Precambrian Shore Beyond
 the Muskeg
 Alice Bastedo

63 A Cold Northern Panorama of
 Arctic Islands and Distant
 Headlands, Lancaster Sound
 Mason collection

65 Freeze-up After First Snow
 Margaret and Ted Cuddy

67 Swamp in First Snow
 Mason collection

69 Pukaskwa River Cliffs
 Mason collection

71 Dumoine Rock in Light and Shade
 Glen and Christopher Chapman

73 Dry Tributary of the Nahanni River
 Mason collection

75 Abstract Rock and Spruce Trees
 Glen and Christopher Chapman

77 Rounding Cape Gargantua in a
 Stiffening Breeze
 Paul and Judy Mason

79 Cove Near Devil's Warehouse
 Island, Superior
 Mason collection

81 Wave-washed Rock
 Susan and Ken Buck

83 Hidden Crevice from Canoe,
 Superior
 Mason collection

85 Impending Storm, Superior
 Mason collection

87 Approaching Storm, Old Woman
 Bay, Superior
 Nancy and John McFadyen

 Approaching Storm, Old Woman
 Bay, Superior detail

89 In the Wake of a Superior Storm
 Edwin Martin

91 Last Light Before the Storm,
 Superior
 Edwin Martin

93 Rounding Point Canadian in a
 Storm, Superior
 Mason collection

95 Height of the Storm, Georgian Bay
 Bernie Lalonde

97 Hurricane Island
 Mason collection

99 Hostile Shore
 Mason collection

101 Rounding Point Canadian in
 Approaching Storm, Superior
 Mason collection

103 Pine Island Storm
 Private collection

105 Afterglow
 Private collection

107 A Wave-washed Vein of Rock
 Mason collection

109 Surf on Rocky Point, Old Woman
 Bay, Superior
 Mason collection

111 Crashing Surf
 Mason collection

113 Lakeshore, Fog and Surf
 Mason collection

 Lakeshore, Fog and Surf detail

115 Impression of Wilberforce
 Glen and Christopher Chapman

117 In the Depths of Wilberforce
 Canyon I
 Mason collection

119 Brink of Wilberforce Falls,
 Hood River
 Mason collection

121 Denison Falls, Dog River, North
 of Superior
 Michael Watts

123 Cascade Falls, Lake Superior
 Private collection

125 Virginia Falls, Nahanni River
 Mason collection

127 Virginia Falls, Nahanni River detail

129 Wilberforce Falls, Dry Channel,
 Hood River
 Mason collection

131 Wilberforce Falls, Dry Channel,
 Hood River, details

133 Upper Wilberforce Falls, Hood
 River, Sketch
 Private collection

135 Petawawa Haystacks
 Mason collection

137 Hidden Path by Folded Rock
 Margaret and Ted Cuddy

139 Pyramid Rock Rapids, Petawawa
 River
 Karen MacKay

141 Red Canoe in Rapids, Fall Colours,
 Petawawa River
 Mr. and Mrs. R. W. McLachlan

143 In the Depths of Wilberforce
 Canyon II
 Mason collection

 In the Depths of Wilberforce
 Canyon II detail

145 Cache Rapids, Nahanni River
 Ted and Gloria Maloof

147 Pulpit Rock, Nahanni River
 Brendan Calder

149 Fire at the Confluence of Little
 Nahanni and South Nahanni Rivers
 Ted and Gloria Maloof

151 Alpenglow on the Mountain River
 Mason collection

153 Campfire, Pukaskwa River
 John and Peggy Amatt

155 Campfire Ghosts
 Marla and Barry Bryant

160 A Landscape Fantasy with a Red
 Centre of Interest
 Mason collection

All works are oil-on-paper except *Pine Island Storm*, page 103, which is water-colour.

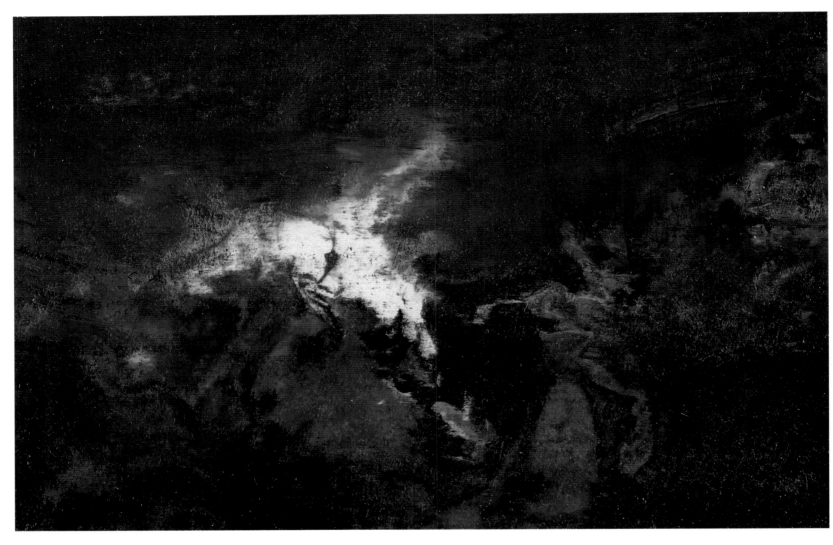

A LANDSCAPE FANTASY WITH A RED CENTRE OF INTEREST 3¼ x 2¼ inches